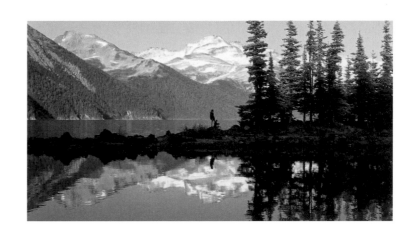

BRITISH COLUMBIA

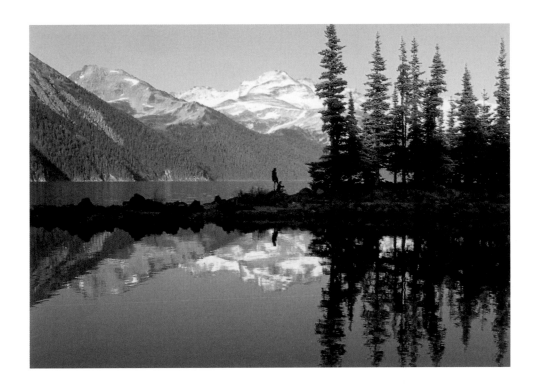

WHITECAP BOOKS

Cover and book design by Steve Penner

Text by Tanya Lloyd
Edited by Elaine Jones
Proofread by Lisa Collins
Photo editing by Pat Crowe

Printed and bound in Canada by Friesens, Altona, Manitoba

National Library of Canada Cataloguing in Publication Data
Lloyd, Tanya, 1973-
 British Columbia

ISBN 1-55110-521-7

 1. British Columbia--Pictorial works. I. Title II. Series:
Lloyd, Tanya, 1973-
FC3812.L66 1997 971.1'04'0222 C96-919742-0
F1087.8.L66 1997

The publisher acknowledges the support of the Canada Council and the
Cultural Services Branch of the Government of British Columbia in making
this publication possible.

**For more information on this series and other Whitecap Books
titles, visit our web site at www.whitecap.ca.**

On one side of British Columbia, waves from Japan crash against the shores of Long Beach. On the other, the Rocky Mountains rise above alpine meadows. B.C. is Canada's third-largest province—four Great Britains, two Japans, or nine Jamaicas would fit within its borders. Its diverse geography includes more than 7000 kilometres of coastline, towering rainforests, secluded wetlands, and barren ranges. In the Bella Coola valley, lush forest surrounds roaring rivers; in the Okanagan, rattlesnakes wind through a pocket desert.

This province has Canada's fastest-growing population, and as people continue to swell the towns and cities, attention has fallen on the need to preserve its diversity. Provincial and national parks protect more than 2000 species of flowering plants, as well as Canada's widest array of animal habitat. Sharing the parks with wildlife such as grizzlies and bald eagles are human adventurers. They scale the Bugaboo spires, ski the powder of Mount Atlin, and canoe the still lakes of the Cariboo, finding some of the most stunning natural settings in the world.

But B.C. is not all wilderness. First Nations people have lived here for more than 12,000 years, and ever since fur trader Alexander Mackenzie became the first white man to cross the continent in 1793, the province has endured a turbulent history. The fur trade, the gold rush, and the building of the CPR lured thousands of people. Today there are reminders of these wild days in boomtowns of the Interior such as Barkerville and Fort Steele. There are also modern metropolises, including Vancouver, the province's largest city, and Victoria, the capital. The mild winters and community atmosphere of these cities have earned residents a reputation for easygoing friendliness and have prompted eastern Canadians to dub southern B.C. "lotus land."

To protect their lifestyles and the province's natural resources, British Columbians continue to work to find a balance in the province. Increasingly, industry, environmentalists, the public, and the provincial government are cooperating to manage natural resources and protect the array of forests, marshes, and mountain peaks that hold the promise of a prosperous future. Through continued efforts, B.C. hopes to uphold its motto: *splendor sine occasu*, splendor without diminishment.

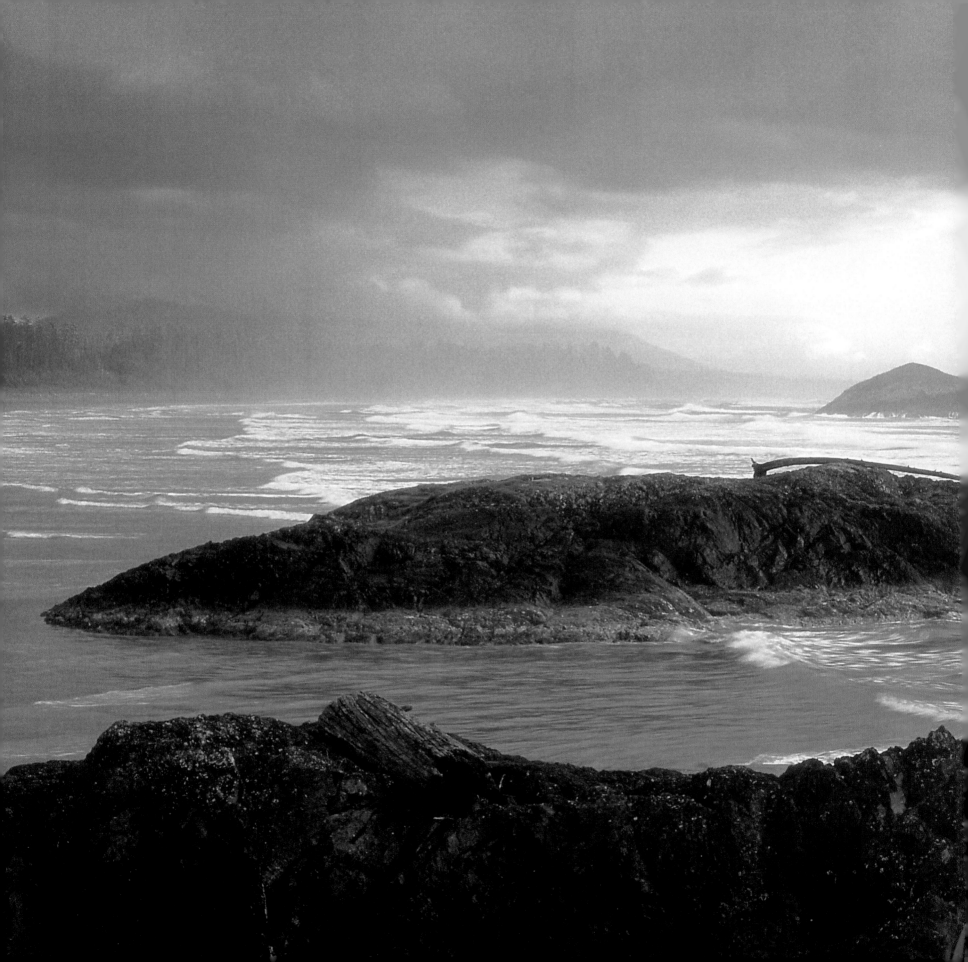

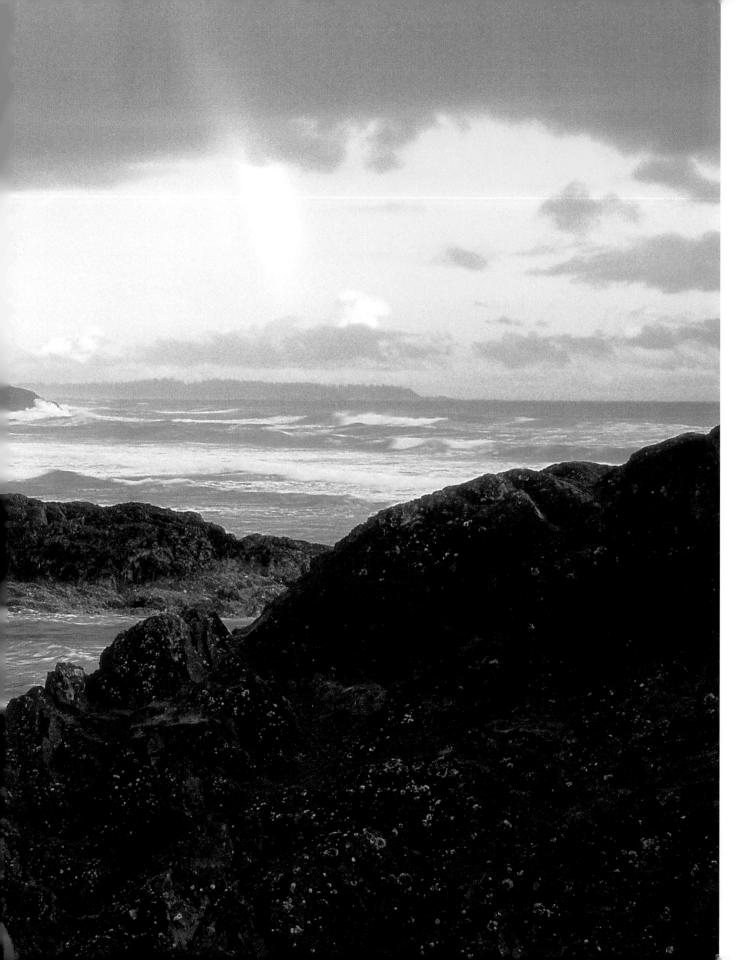

Waves sweep Long Beach, an 11-kilometre stretch of sand and surf that forms part of Pacific Rim National Park on Vancouver Island.

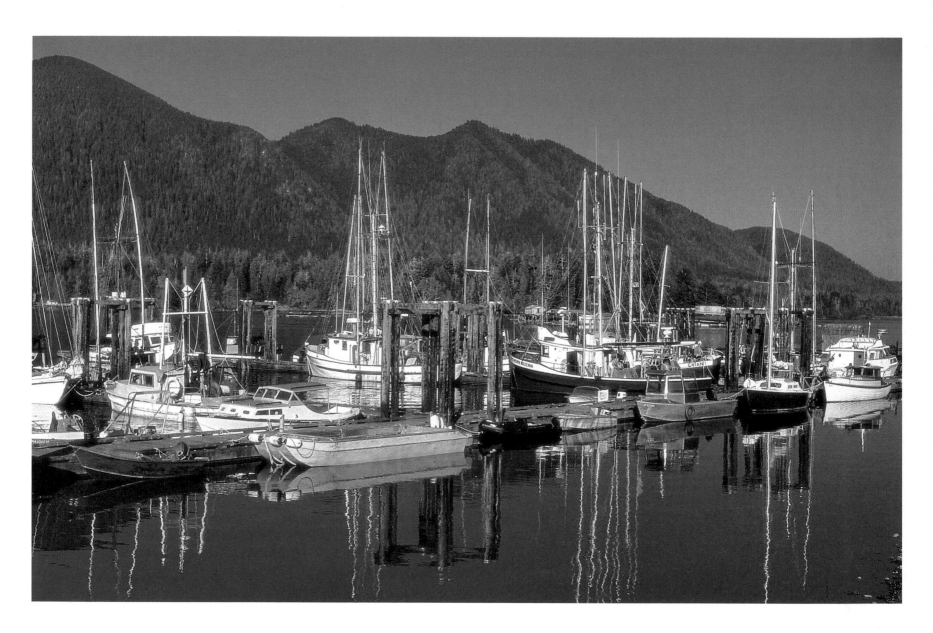

The small town of Tofino on Vancouver Island's west coast is a base for both fishing and whale watching. In the spring, thousands of grey whales pass near the shore on their way to Alaska.

The West Coast Trail was originally built for the workers who serviced the telegraph wire between Victoria and Cape Beale. It was improved in the early 1900s to allow rescuers to reach shipwreck survivors. Now, more than 9000 hikers each year come from all over the world to follow the 72-kilometre route past the old-growth rainforest and rocky shoreline.

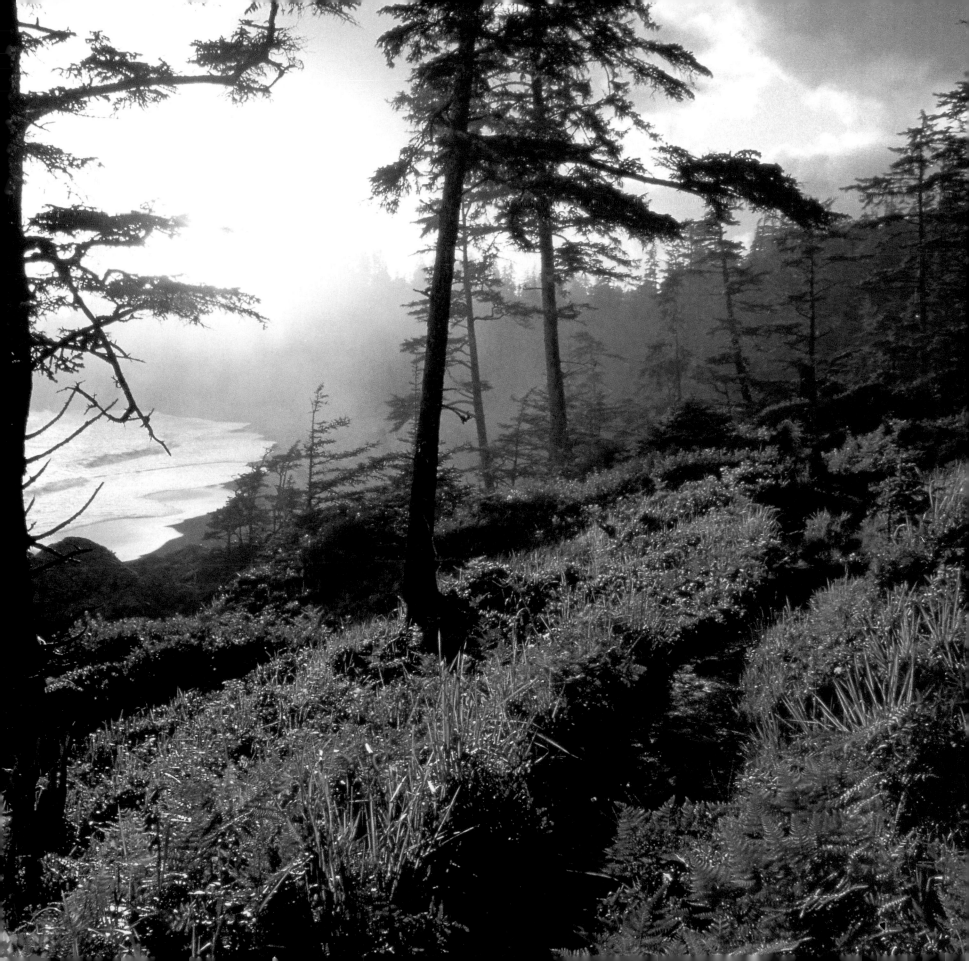

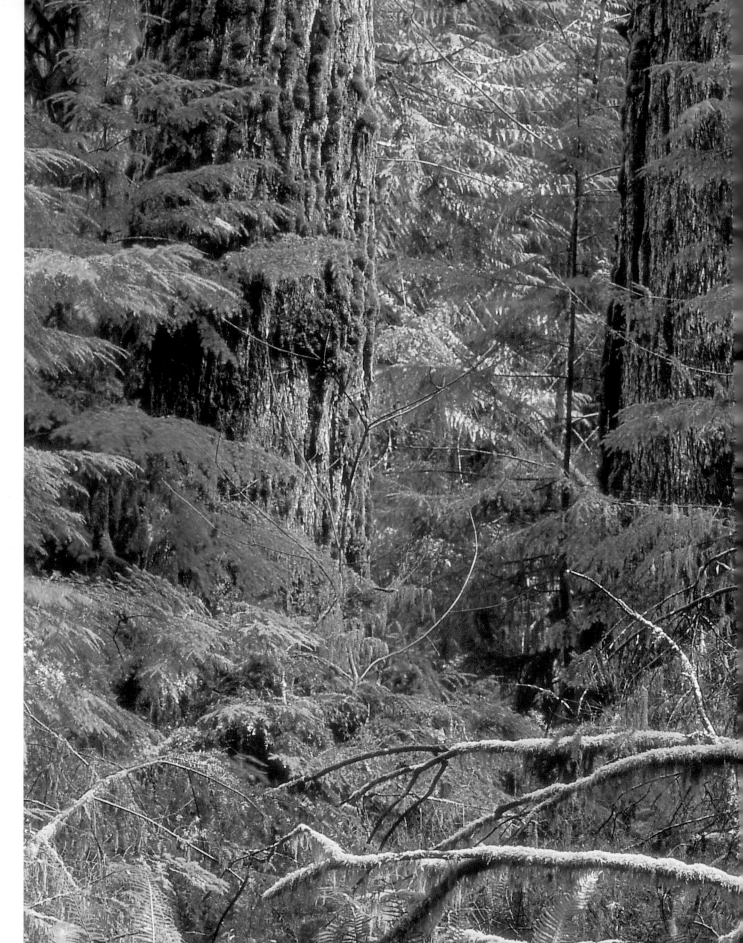

MacMillan Park's Cathedral Grove is aptly named–branches arch into the sky to screen out the sunlight. These 800-year-old trees survived a forest fire that destroyed their surroundings about 300 years ago. Now, the tallest Douglas fir is more than 75 metres high.

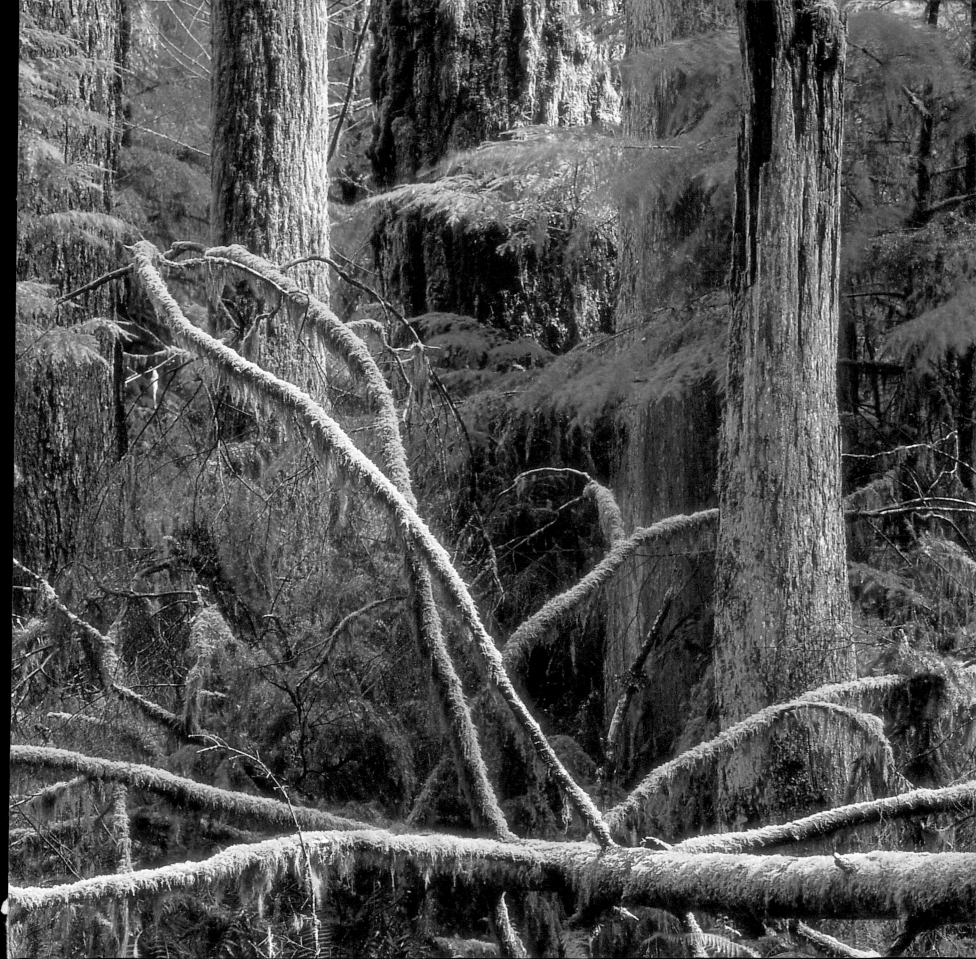

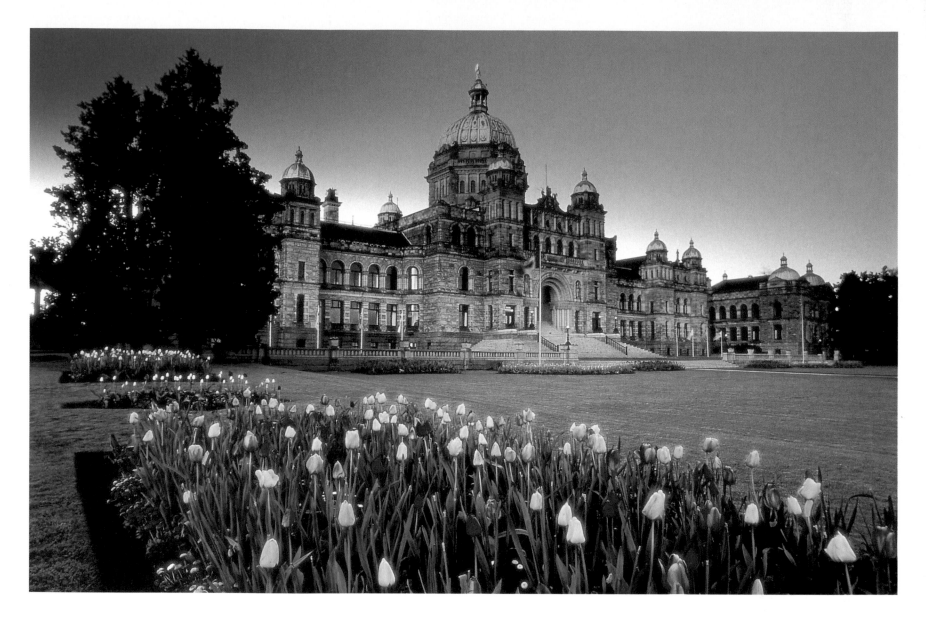

The copper domes of the Parliament Buildings tower over Victoria's Inner Harbour. The architecture and paintings of the interior have been restored, and tours are offered throughout the year.

High tea is a tradition at the Empress Hotel in Victoria, where residents have been called "more British than the British." The hotel was built by the Canadian Pacific Railway in 1907.

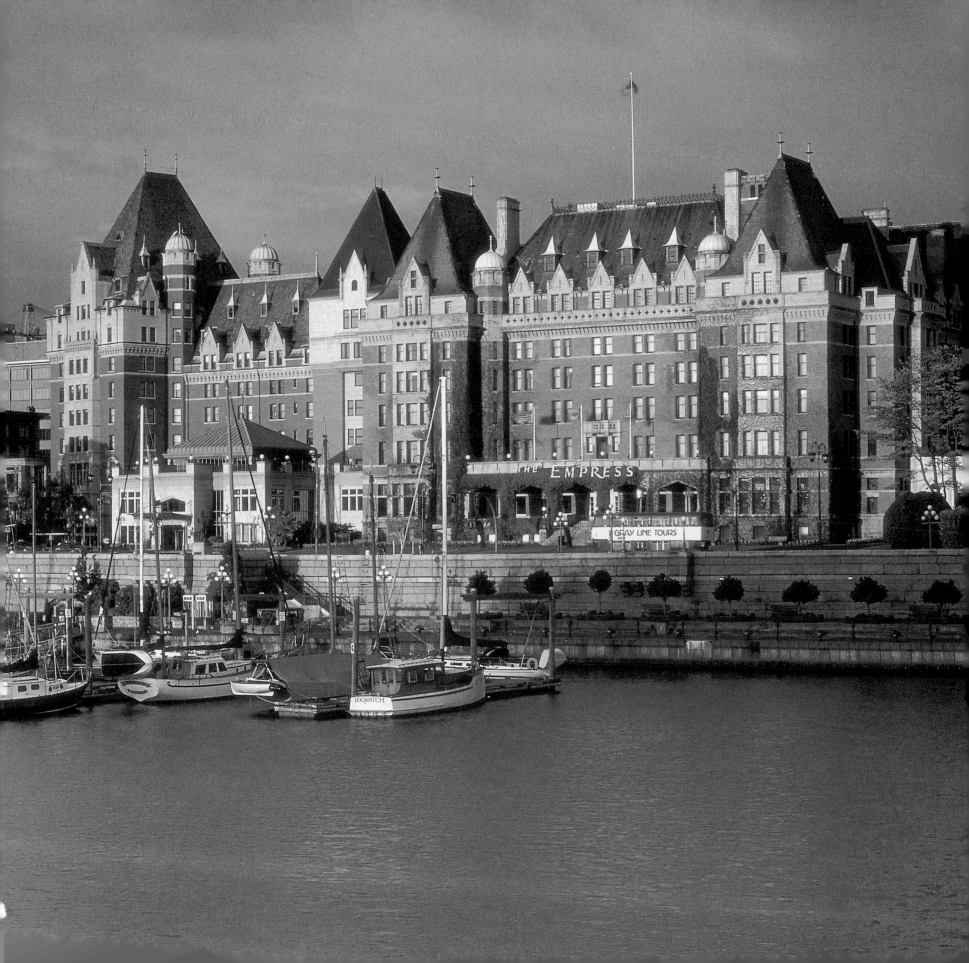

Who would guess that this was once a limestone quarry? Butchart Gardens, on Vancouver Island's Saanich Peninsula, was originally created by Jenny Butchart, wife of the quarry owner. Now more than one million plants dazzle visitors.

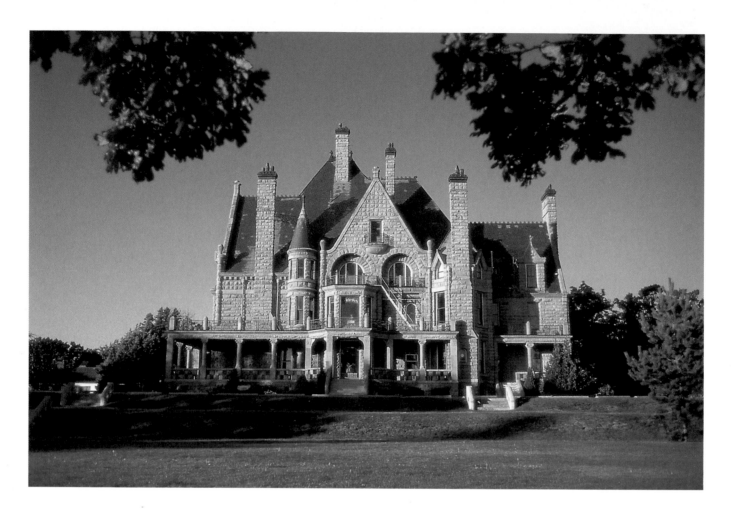

On a Victoria hilltop, nineteenth-century
tycoon Robert Dunsmuir envisioned his
ideal home. He died before
Craigdarroch Castle was completed in
1898, but he left his love of castles
behind. His wife lived here until her
death and their son James Dunsmuir
built Victoria's second castle, now part of
Royal Roads University.

The sand and surf at French Beach Provincial Park near
Victoria make it a favourite with families and picnickers,
but visitors are warned not to venture onto the rocks,
where sudden waves might sweep them away.

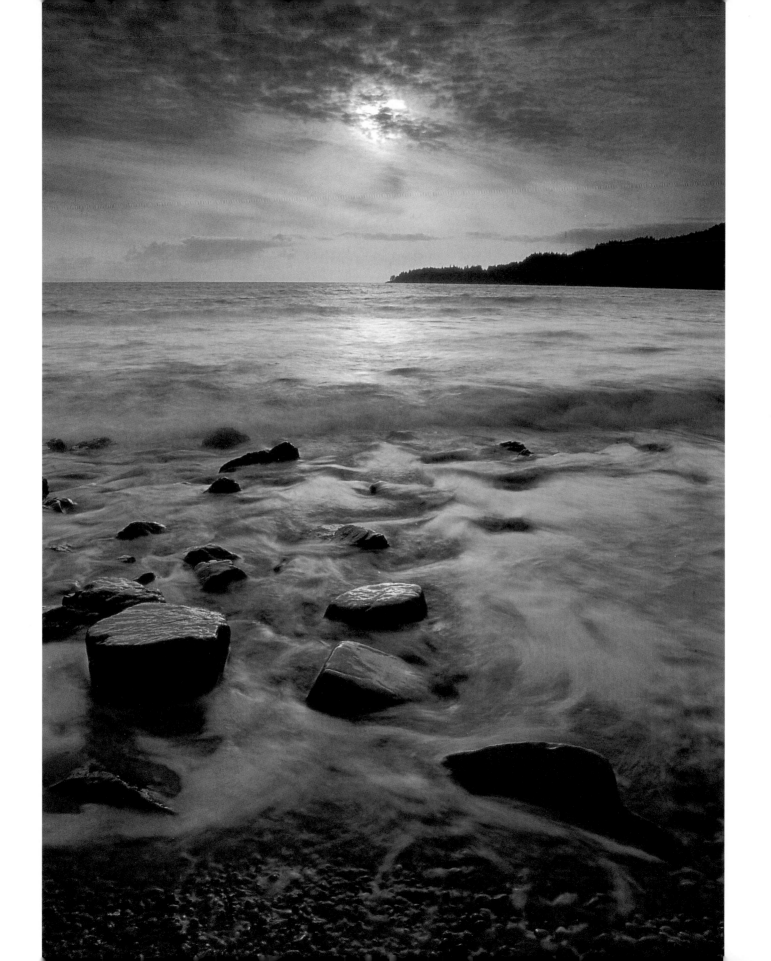

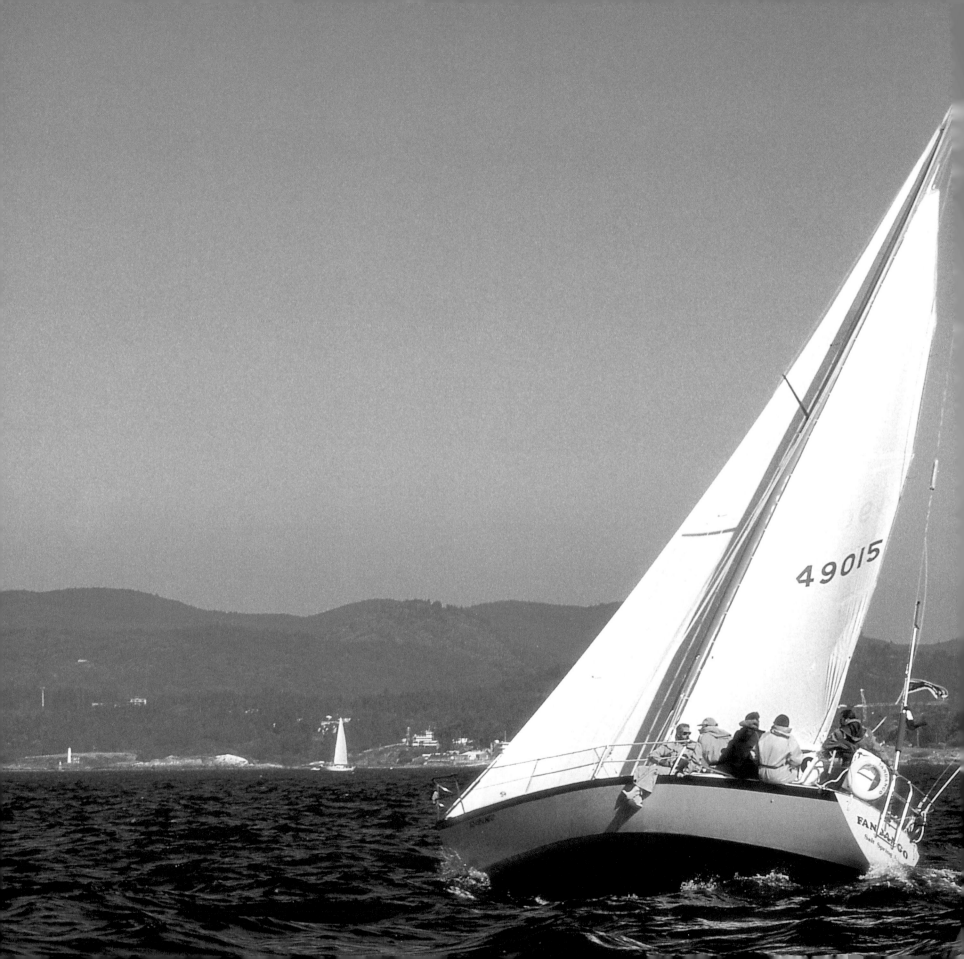

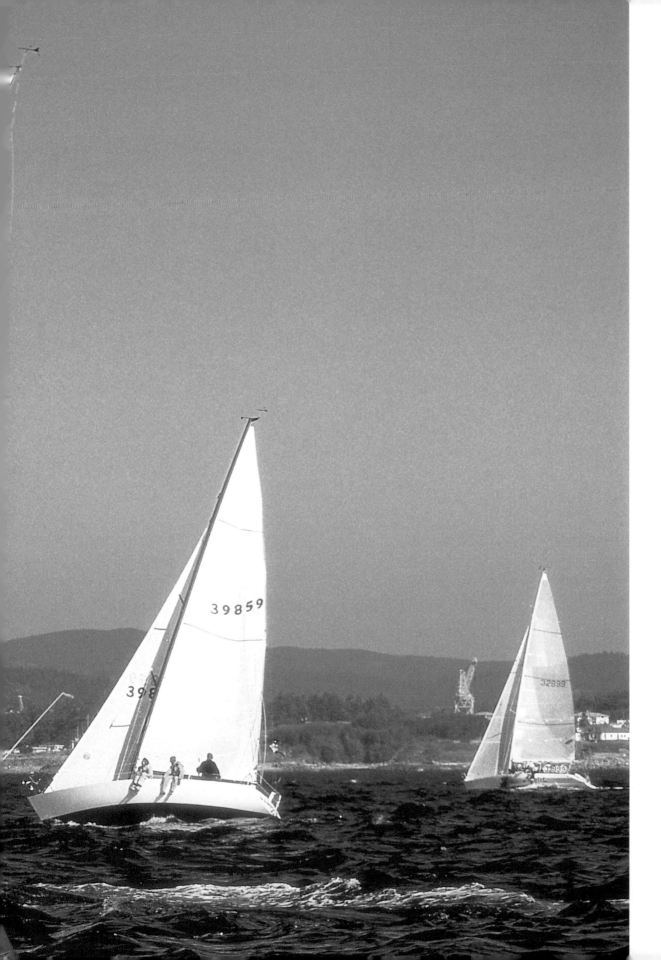

Hundreds of sails are raised each May as competitors in the Swiftsure Yacht Classic race from Victoria to Cape Beale and back again.

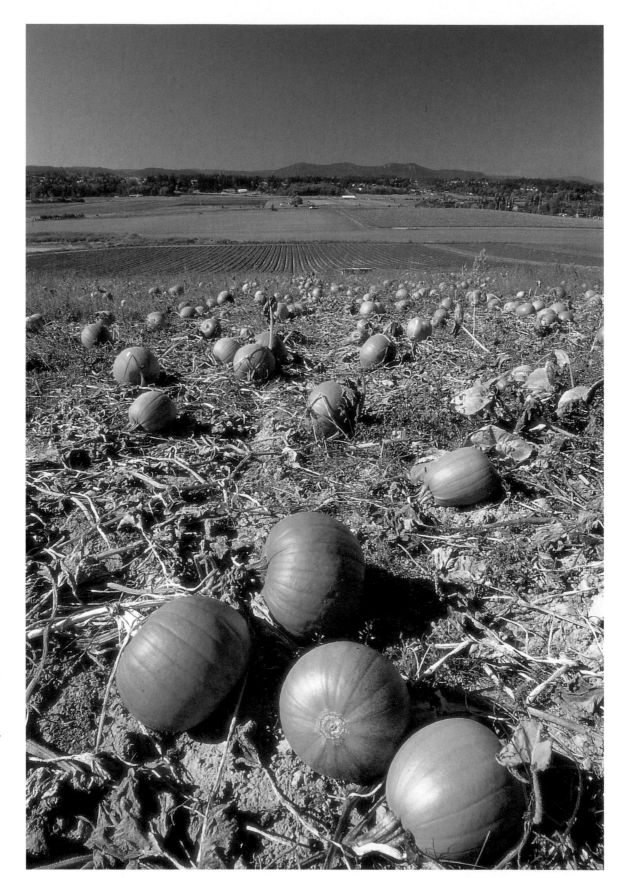

Despite the continued growth of nearby Victoria, there's still room on the Saanich Peninsula for farmland– whether it's a spring crop of daffodils or this autumn pumpkin patch.

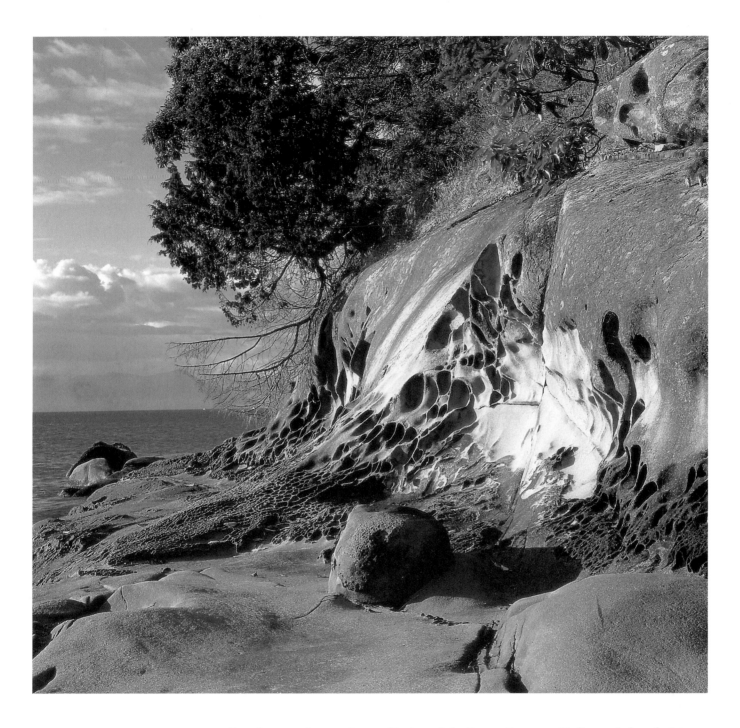

Sandstone formations distinguish Coon Bay on Galiano Island. At low tide, visitors can walk from the bay to a small islet offshore.

Overleaf –
B.C.'s massive superferries pass in front of Mayne Island at the mouth of Active Pass. The boats run year-round between Tsawwassen, on the mainland, and Swartz Bay on Vancouver Island.

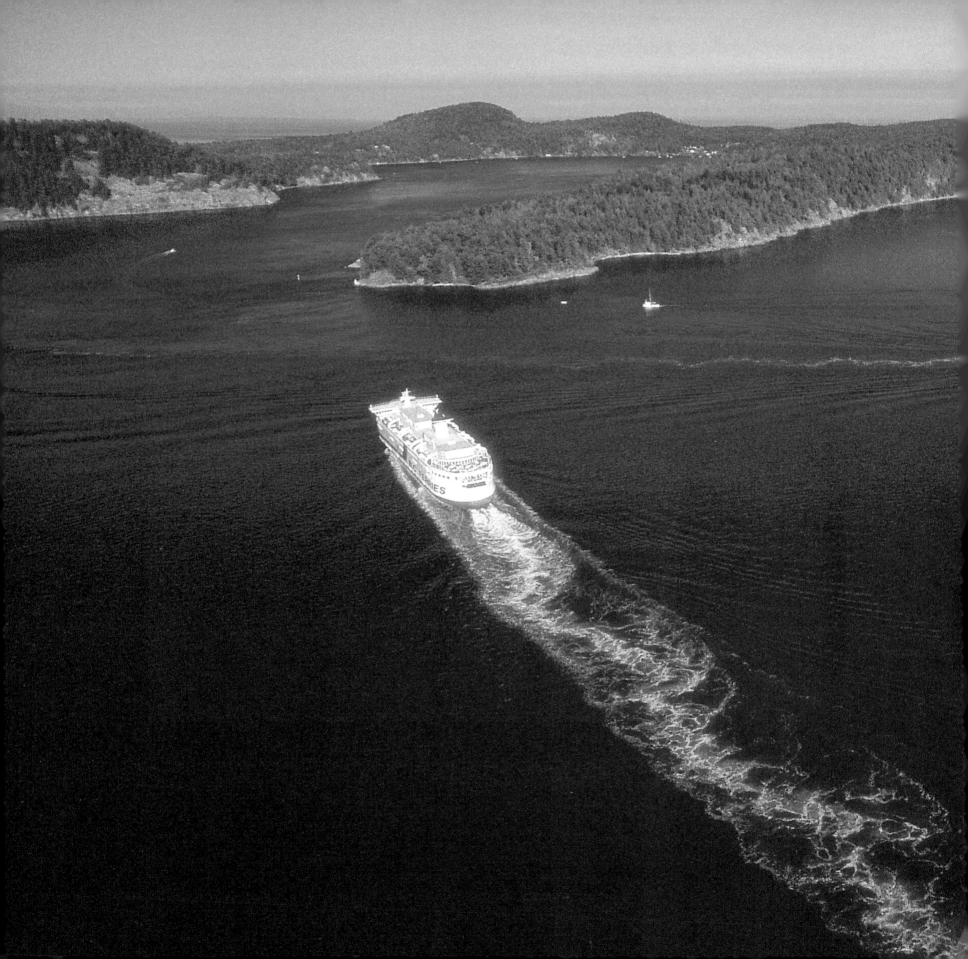

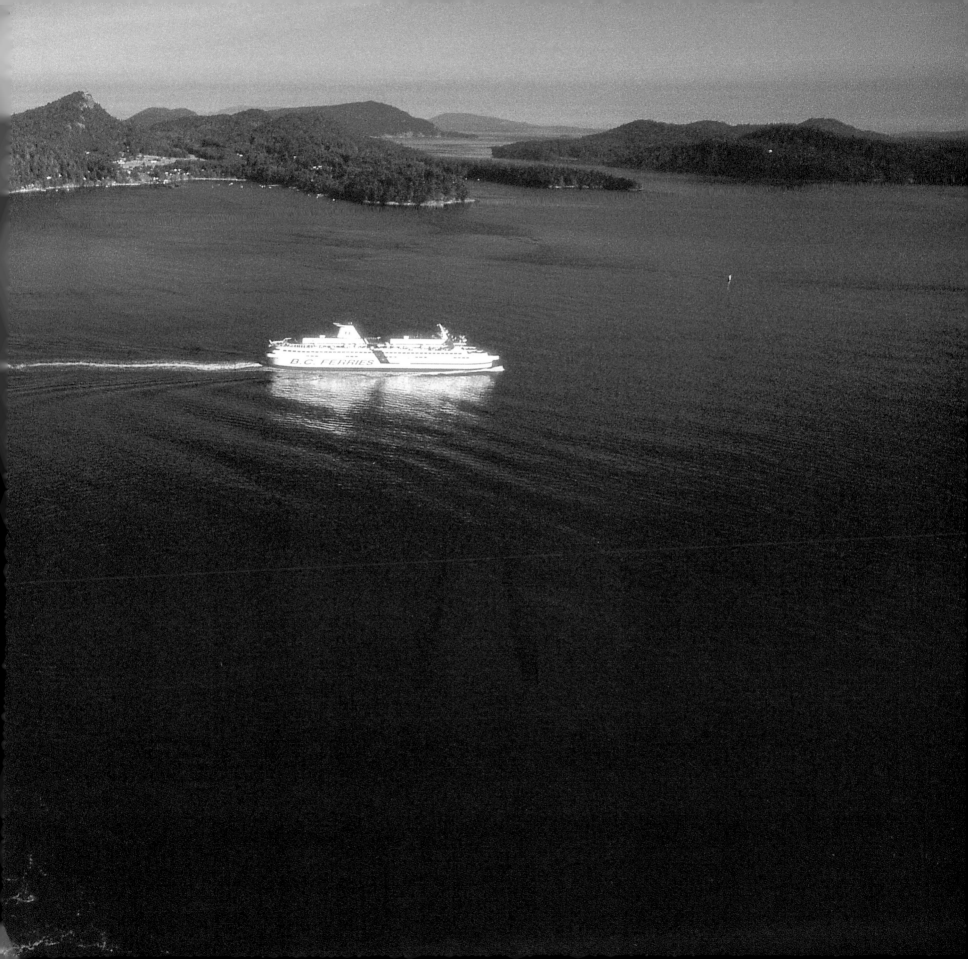

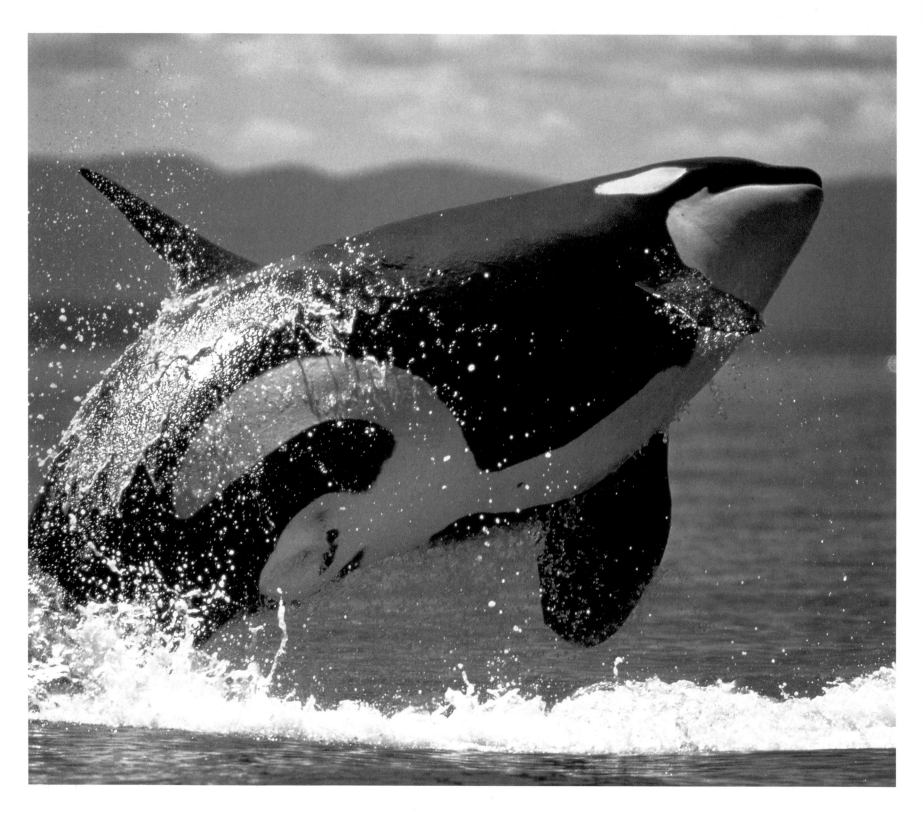

The orca, or killer whale, is one of the most easily recognized whales and can occasionally be seen at close quarters as it ventures into small bays and inlets. This orca was spotted between B.C. and Washington State.

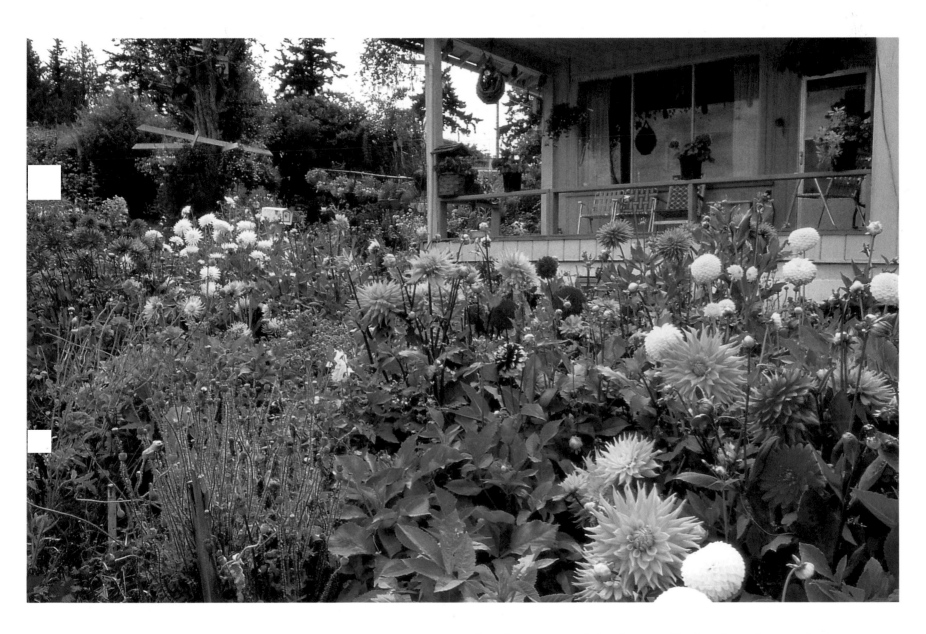

Mayne Island was one of the first Gulf Islands to be settled. The area is rich with heritage homes and farms.

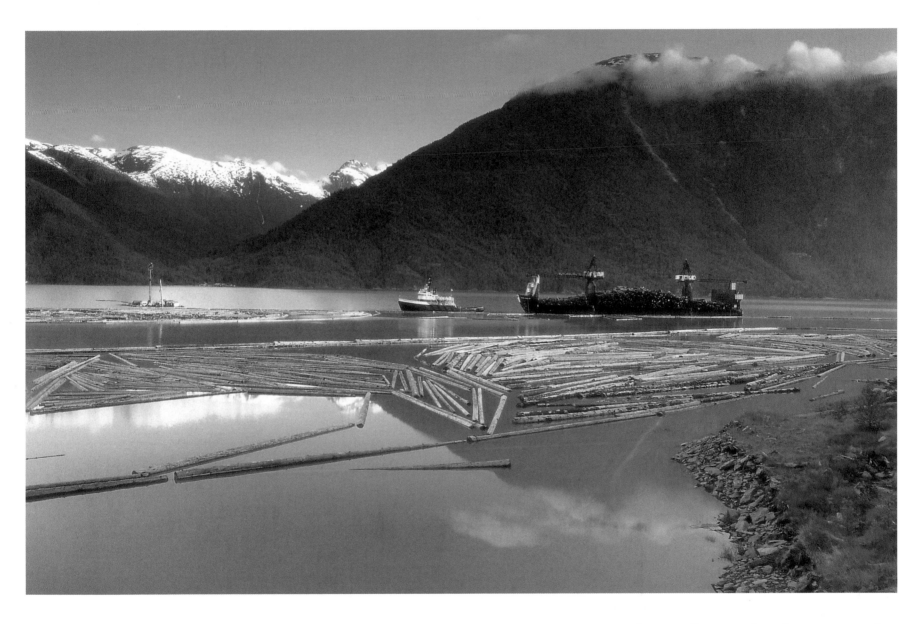

Log booms float on the glassy water of Bella Coola Harbour.

Once owned by the B.C. Whaling Company, the property above Whaling Station Bay on Hornby Island is now the idyllic site of waterfront homes and summer cottages. The bay's sandstone slabs soak up the sun and make it a popular spot for sunbathers.

Artist and dancer Randy Bell puts the finishing touches on a ceremonial dance mask. He is a member of the Kwagiulth people, whose traditional lands are on Vancouver Island.

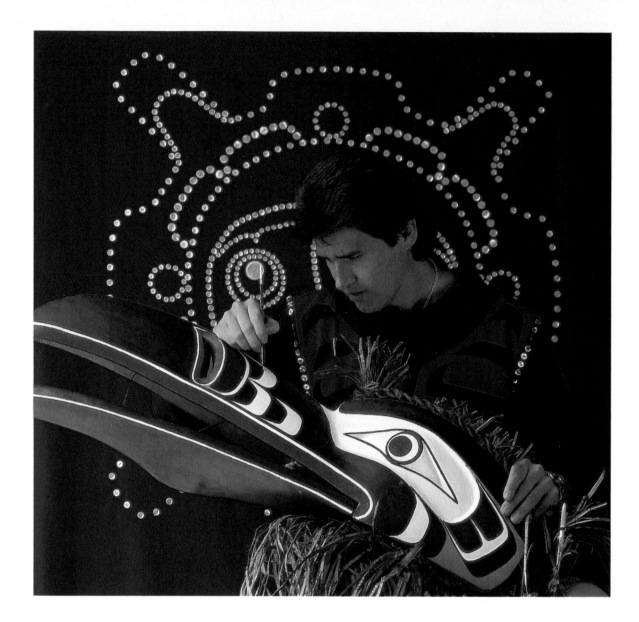

A sailboat rests quietly along the coast of Princess Royal Island, off the west coast near Kitimat.

OVERLEAF –
Sunset silhouettes one of more than 150 islands and islets that make up the Queen Charlotte Island Archipelago, near Murchison Island in the South Moresby National Park Reserve.

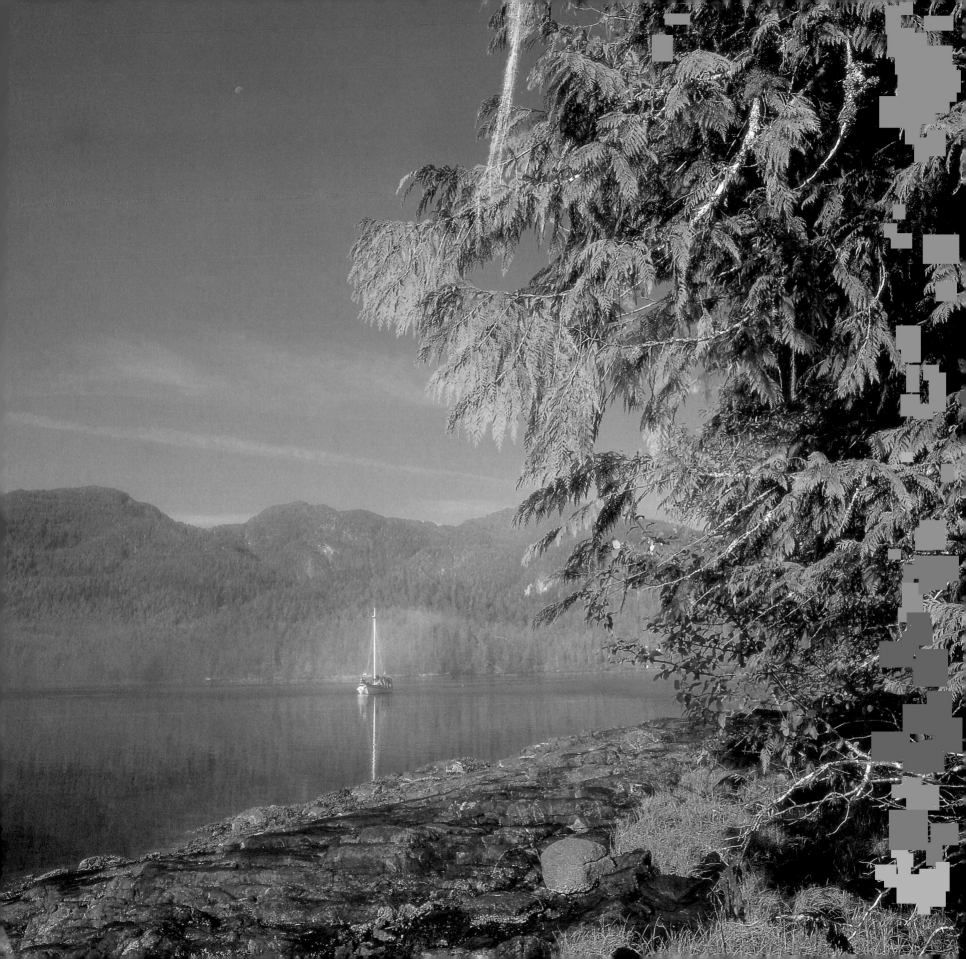

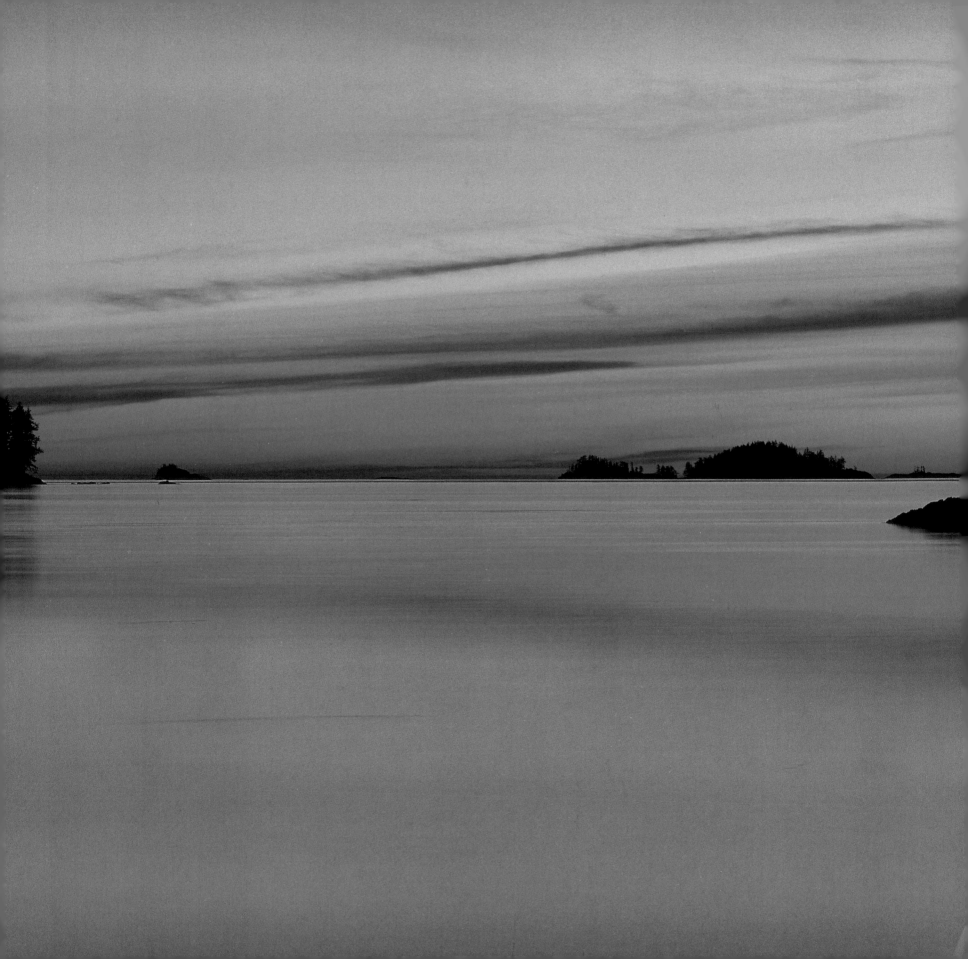

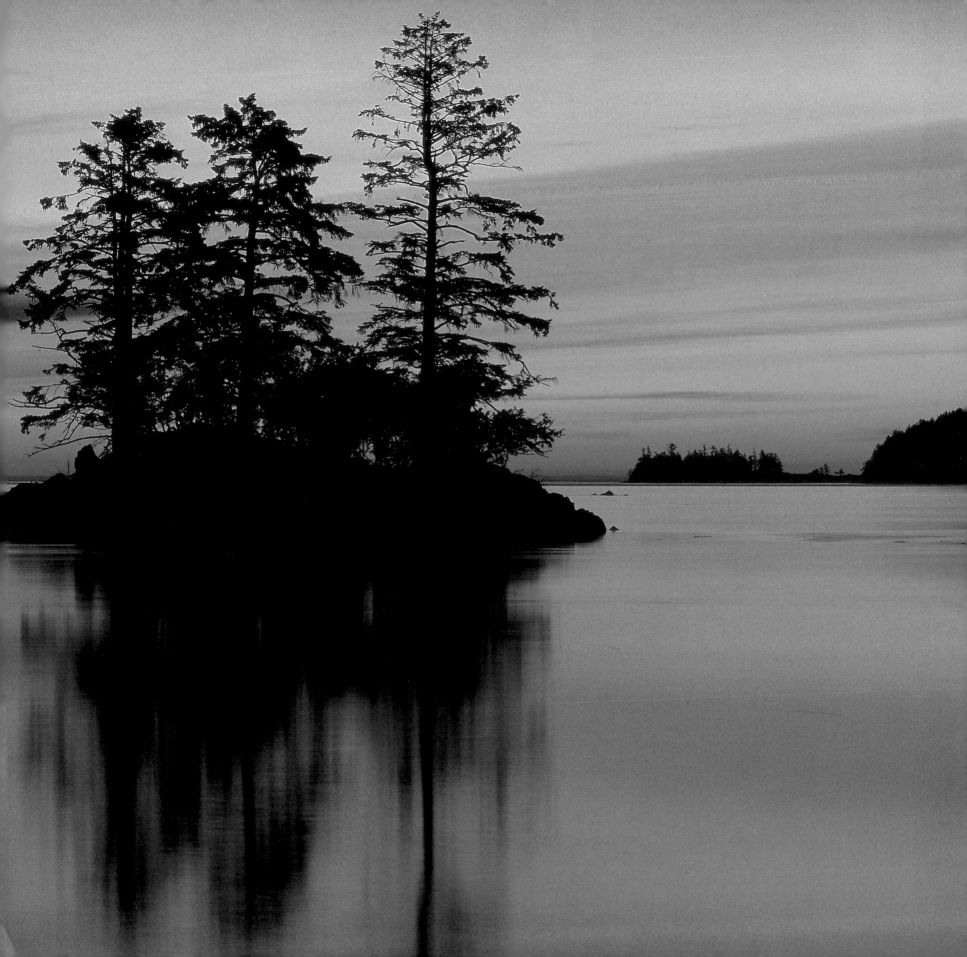

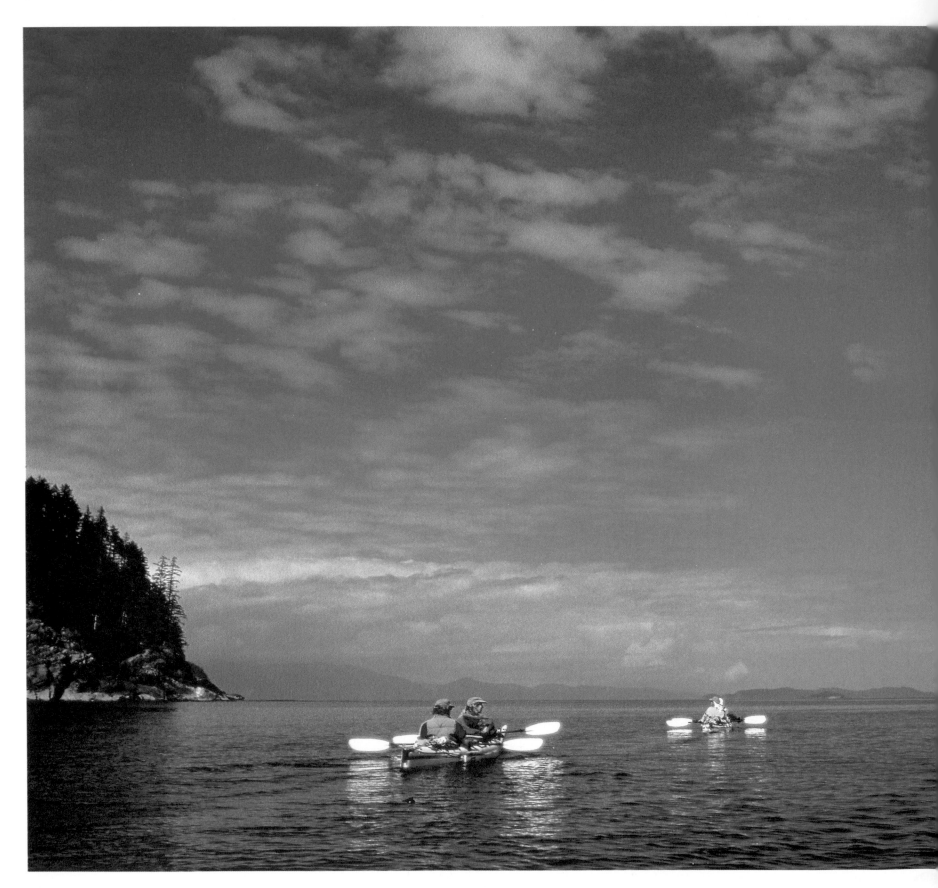

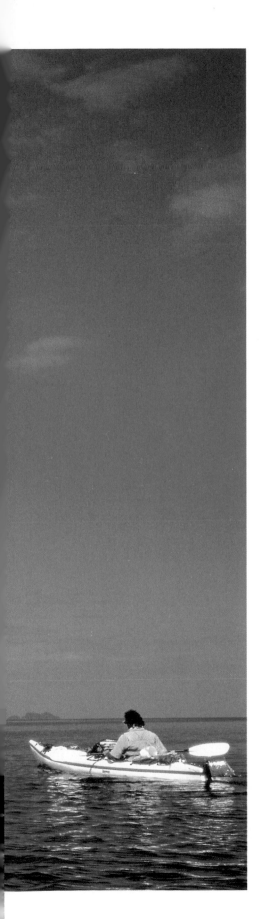

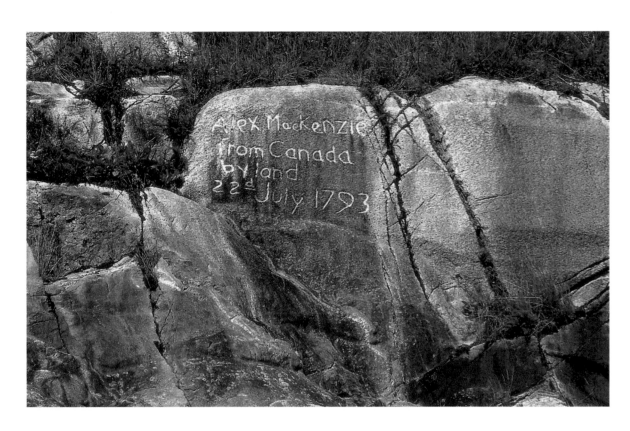

In 1793, Alexander Mackenzie and his native guides canoed down the Bella Coola River to arrive on the west coast. He was the first white man to make the journey across the continent to the Pacific.

Kayakers paddle near the shore of one of the Queen Charlotte Islands, where the rainforest holds hundreds of bird and animal species, and some of the world's tallest trees.

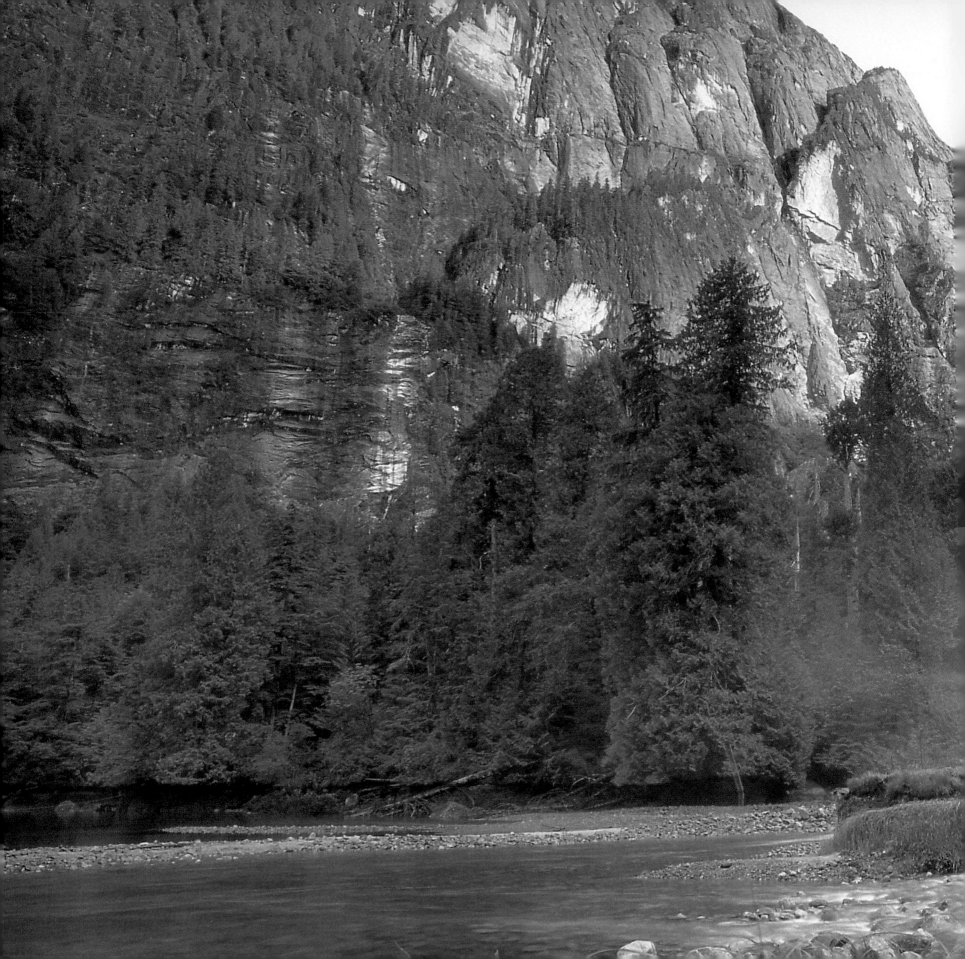

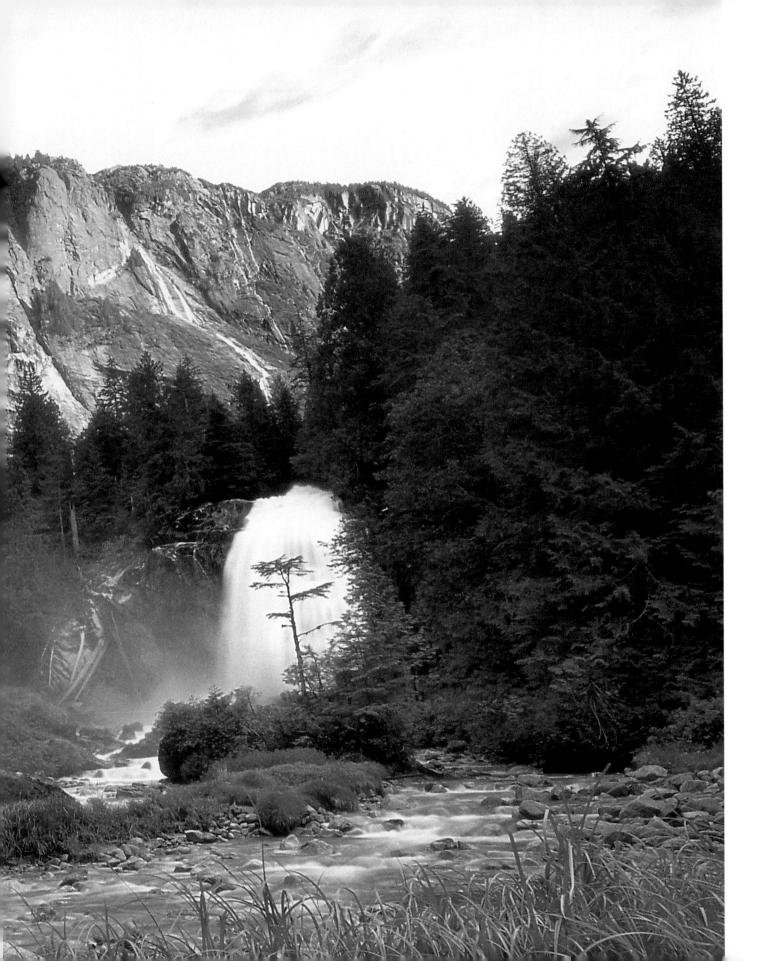

Chatterbox Falls is one of more than 60 waterfalls that roar down the cliffs at Princess Louisa Inlet each summer, when the snow and glaciers above are melting most quickly.

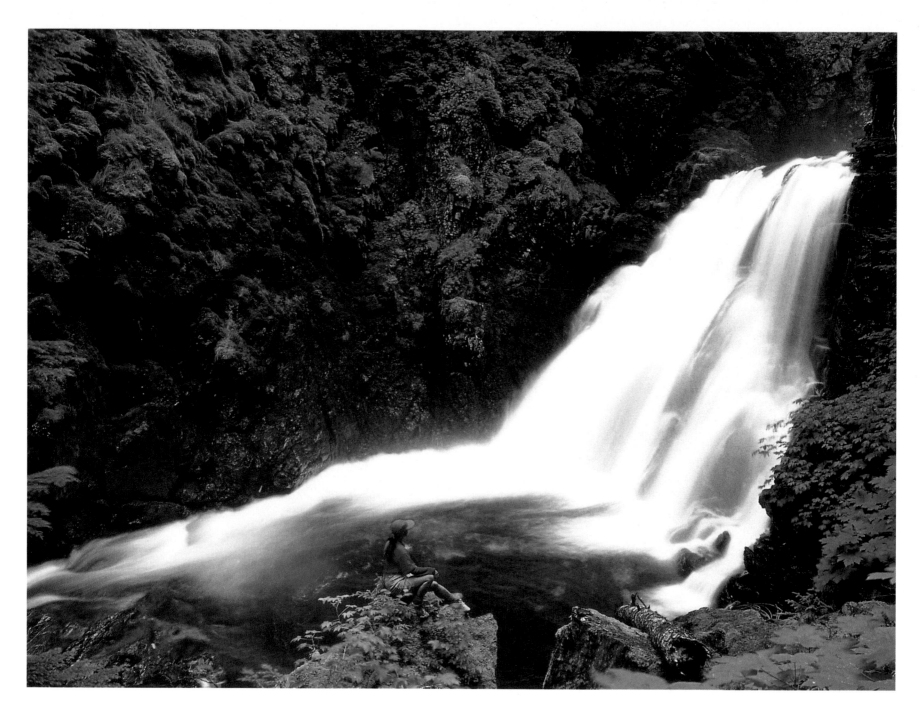

In the lush forest of the Bella Coola Valley, a hiker rests under the spray of a waterfall.

Weather-worn totems and fallen house timbers are all that remain of the once-thriving village of Ninstints, where smallpox killed most of the native population. Anthony Island Provincial Park now protects the poles, and the area has been declared a UNESCO World Heritage Site.

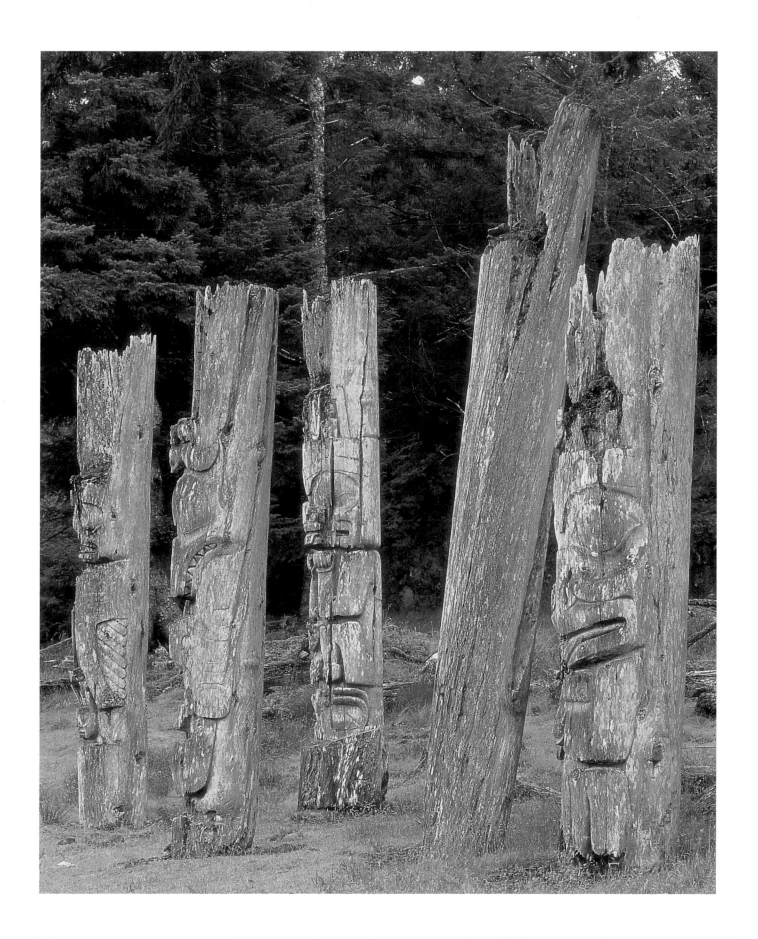

Passengers travel between North Vancouver and Squamish on BC Rail's Royal Hudson steam train, a 65-kilometre trip through some of the province's most spectacular scenery.

FACING PAGE –
Campers enjoy the early-morning stillness of Garibaldi Lake. The campsites here are a four-hour hike from the nearest parking lot– those who make the climb have earned the view.

OVERLEAF –
One of B.C.'s most popular wilderness areas, Garibaldi Provincial Park is a haven for hikers, campers, and skiers.

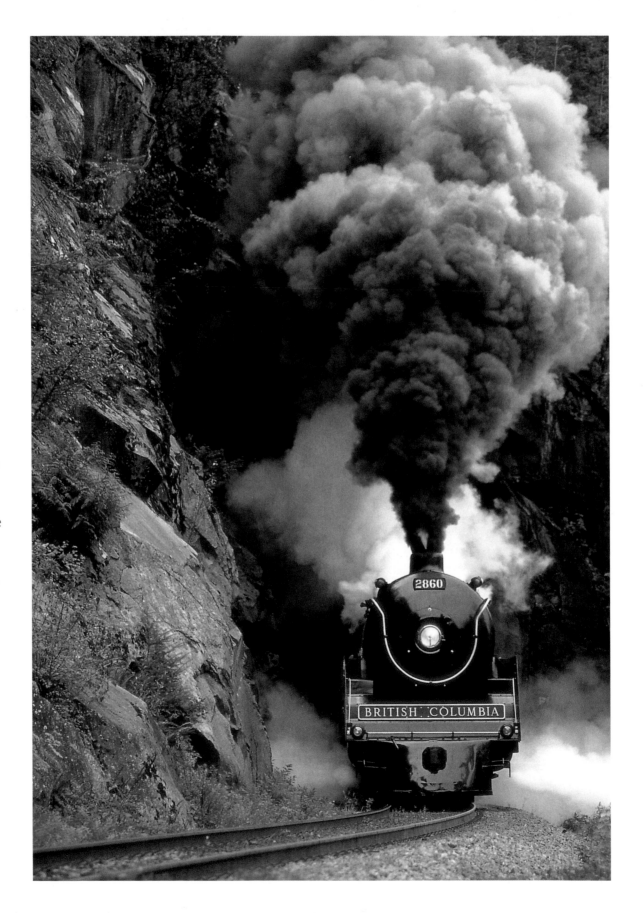

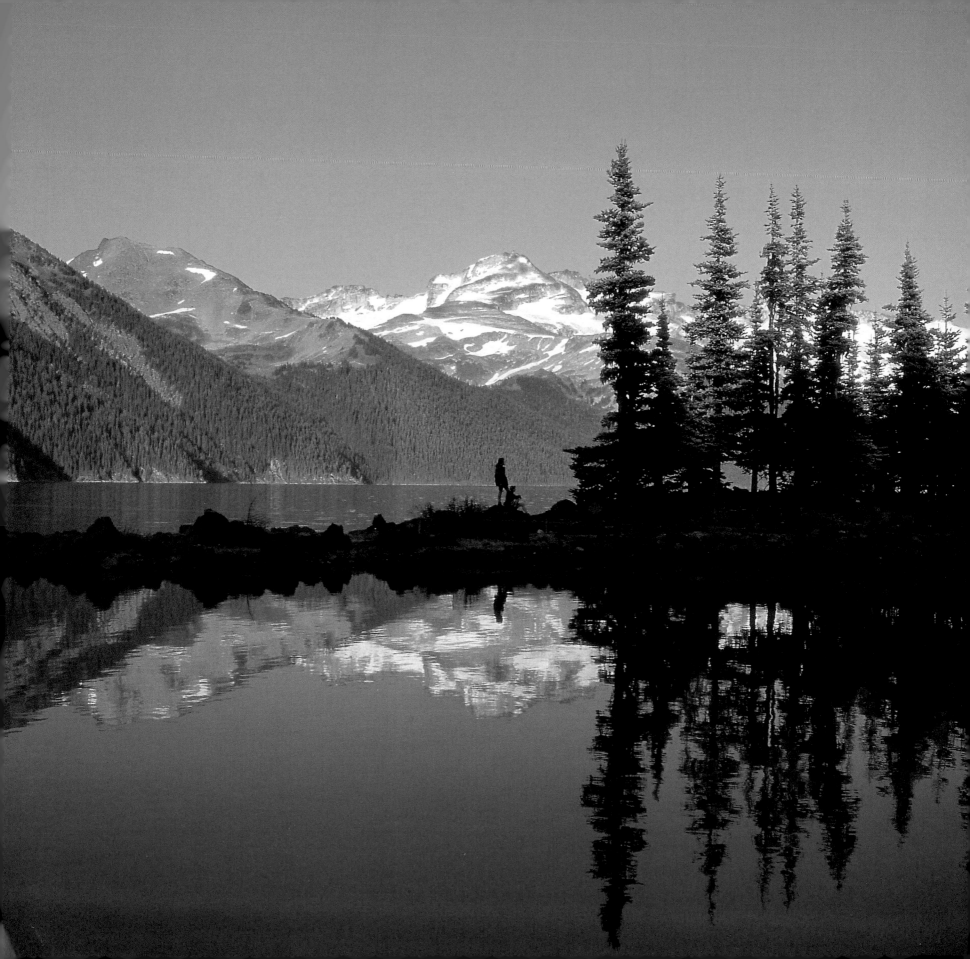

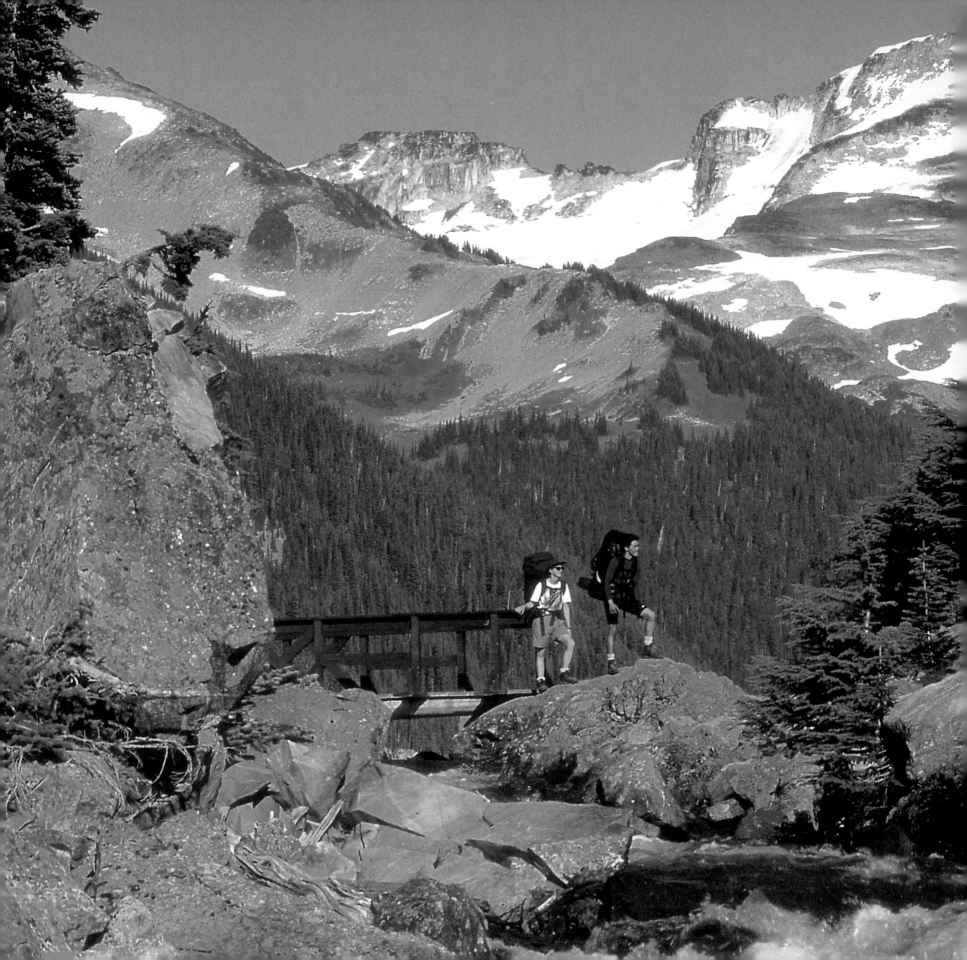

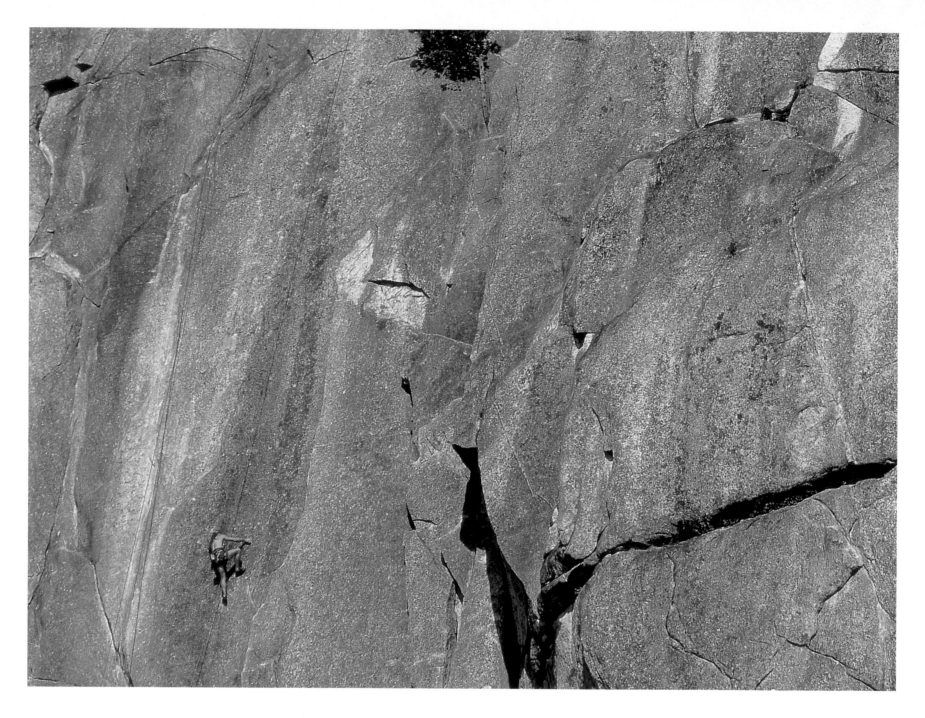

Squamish boasts some of the most difficult rock-climbing routes in Canada, and this climber has a long way to go.

A skier angles quickly through the powder on Mount Atwell, in Garibaldi Park.

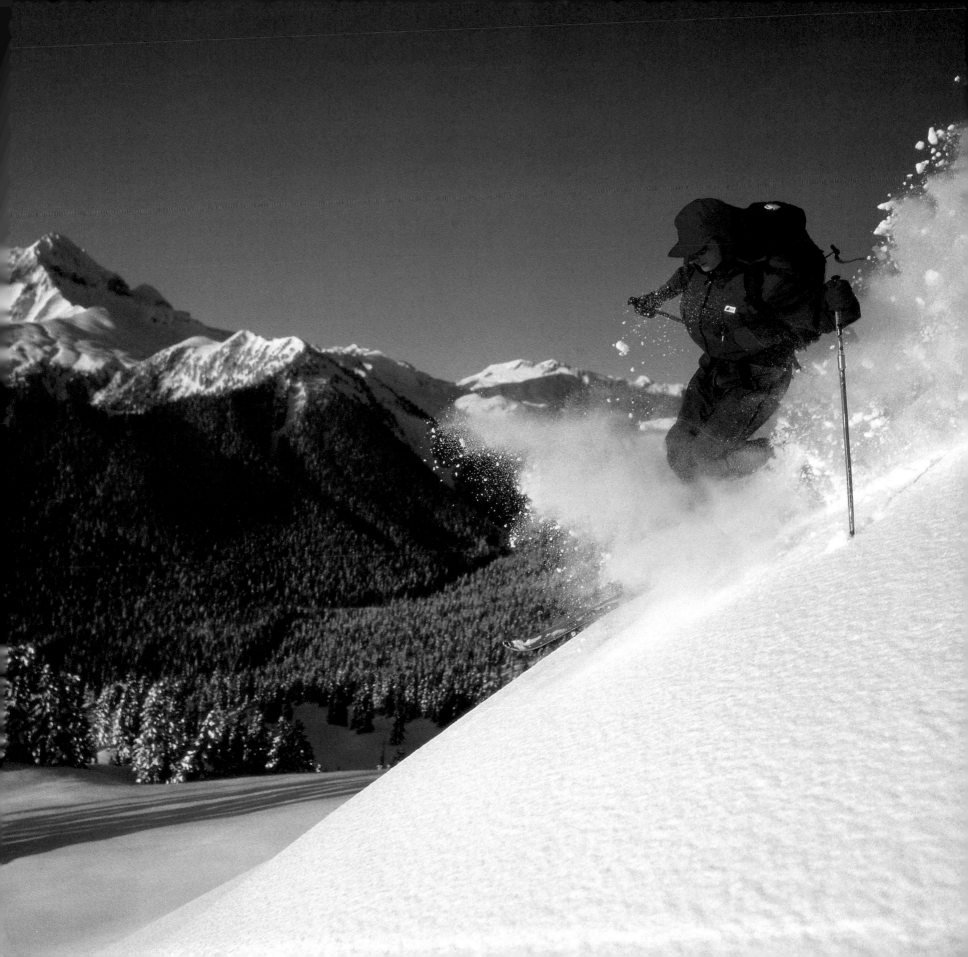

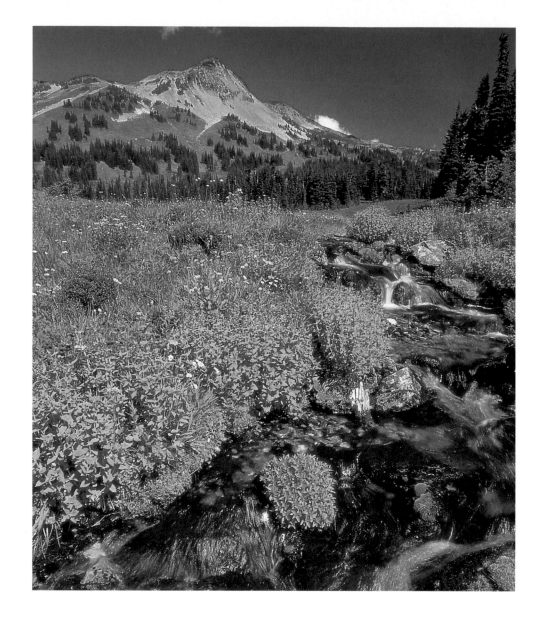

Near the centre of Garibaldi Provincial Park, 2315-metre Black Tusk rises above a wildflower-carpeted meadow. Climbers must carefully scale the loose rock of a narrow, 100-metre chimney to reach the peak.

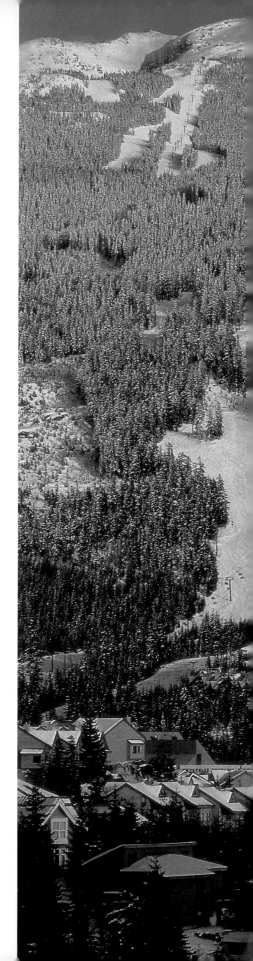

The ski runs of Blackcomb Mountain rise above Whistler Village. Just north of Vancouver, this is one of the most popular ski resorts in North America.

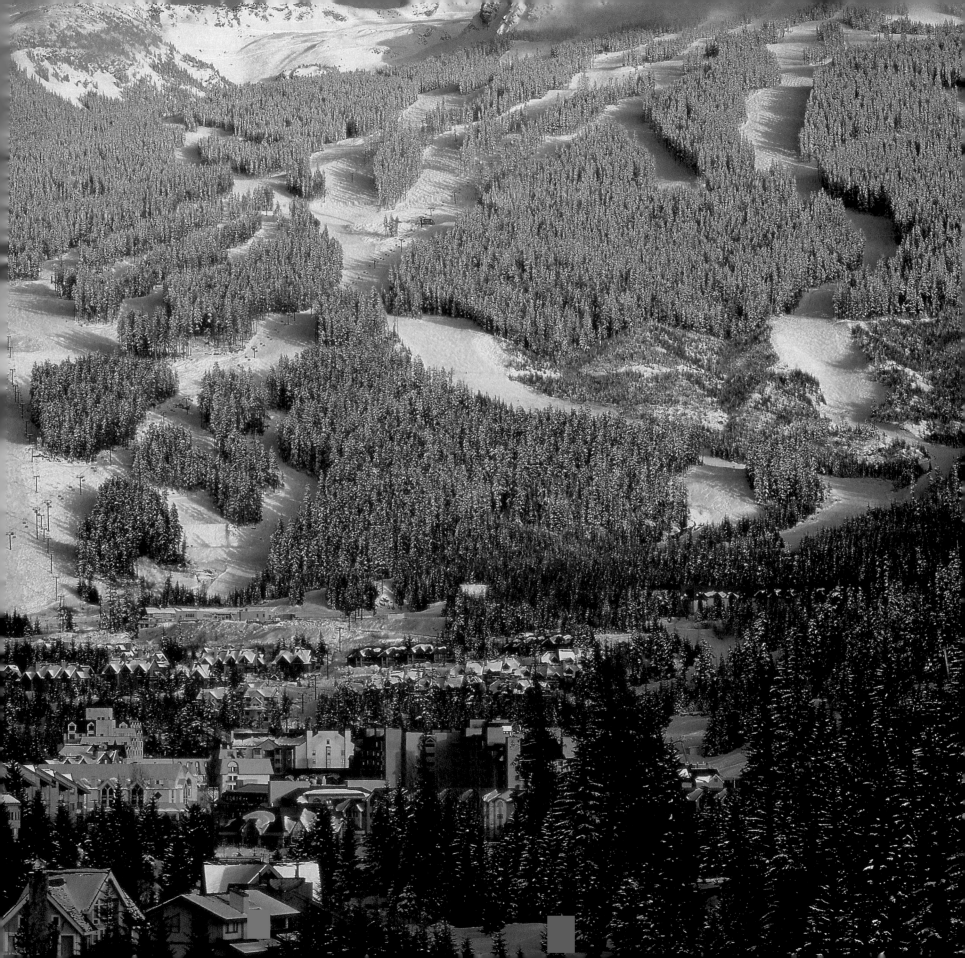

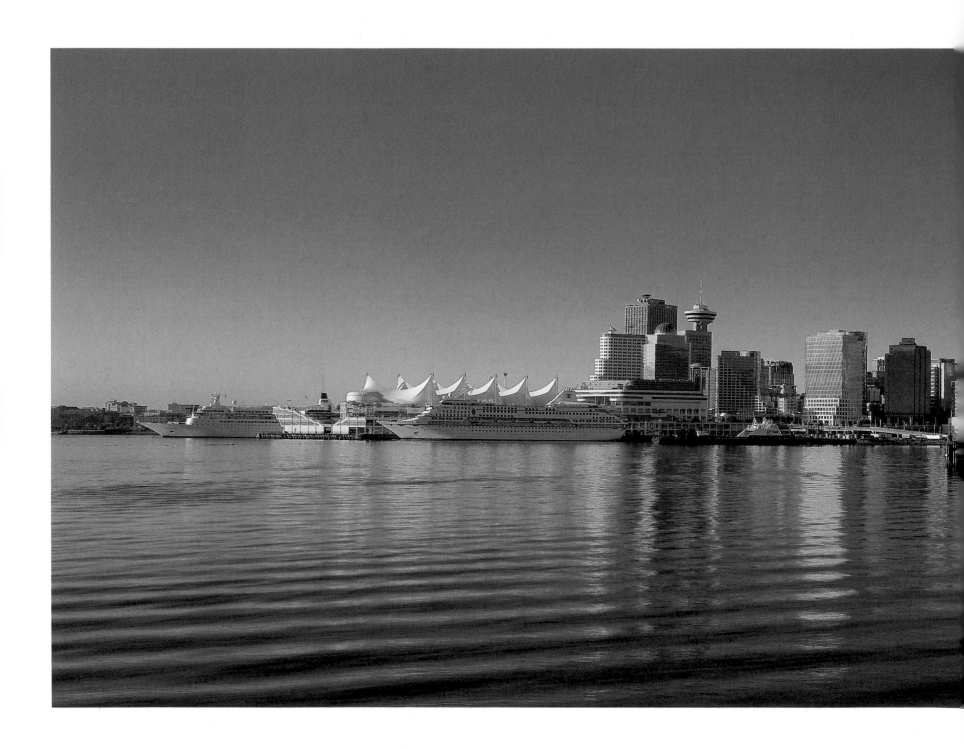

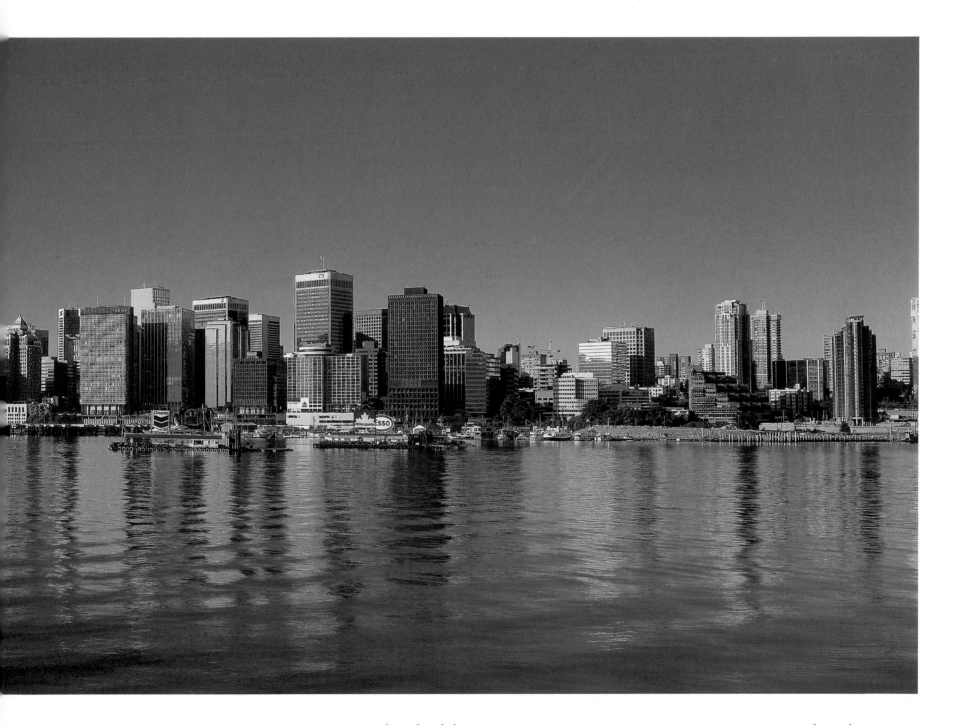

Canada's third–largest city, Vancouver is a stunning juxtaposition of modern highrises and natural beauty. Burrard Inlet forms the northern edge of downtown, and pleasure boats, cruise ships, and tankers stream through its waters.

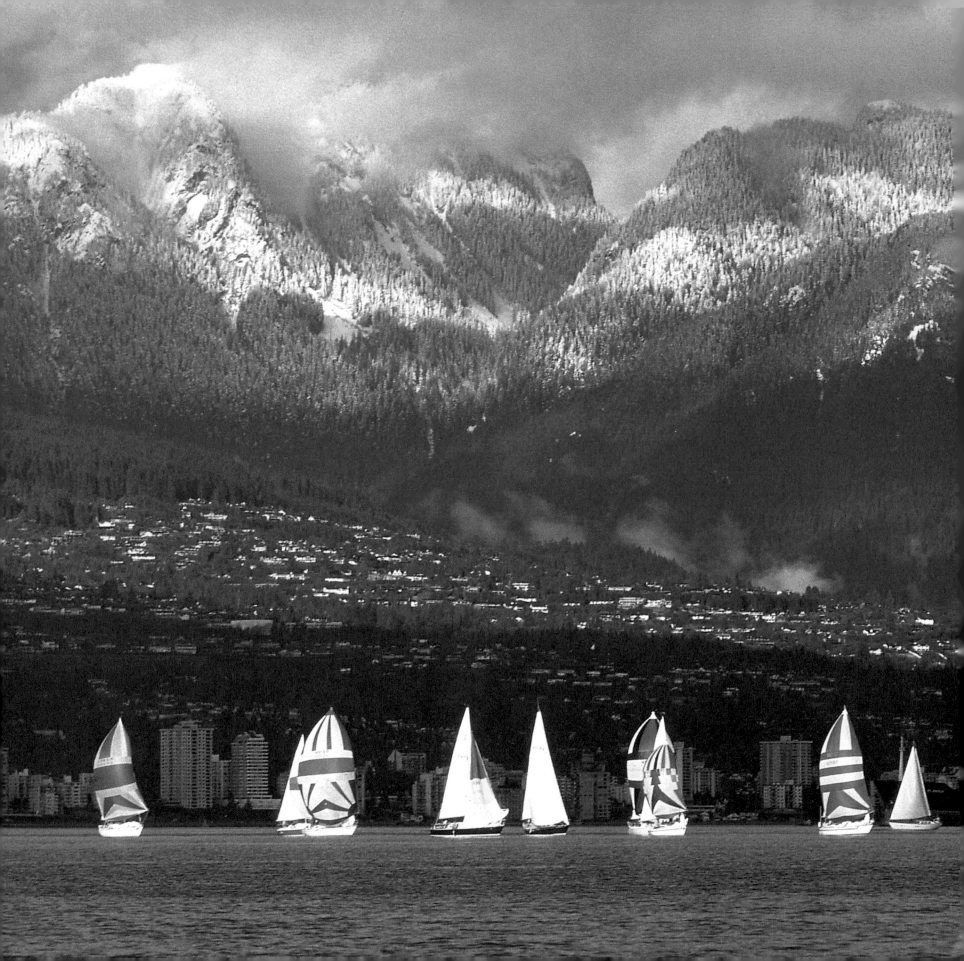

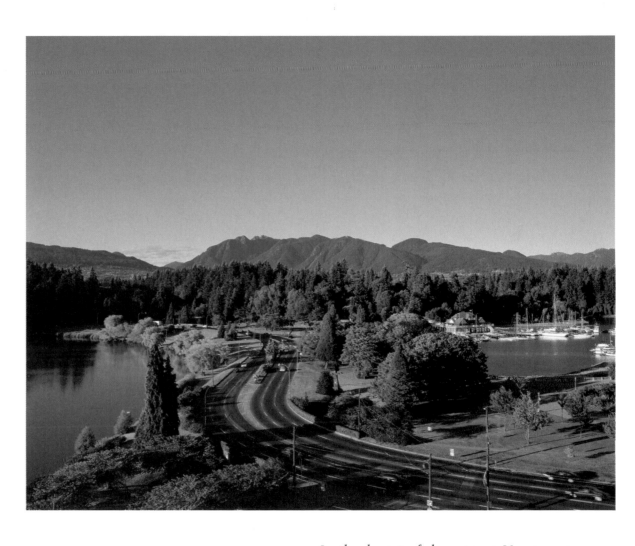

In the heart of downtown Vancouver, Stanley Park is a refuge of forested hillsides, ponds, and seashore. The 405-hectare park was set aside by the city council in 1886. They dedicated it to "the use and enjoyment of people of all colours, creeds and customs for all time."

Even in British Columbia's largest city, people have a passion for outdoor activities. Because of Vancouver's prime location on the Strait of Georgia, sailing is a popular pastime.

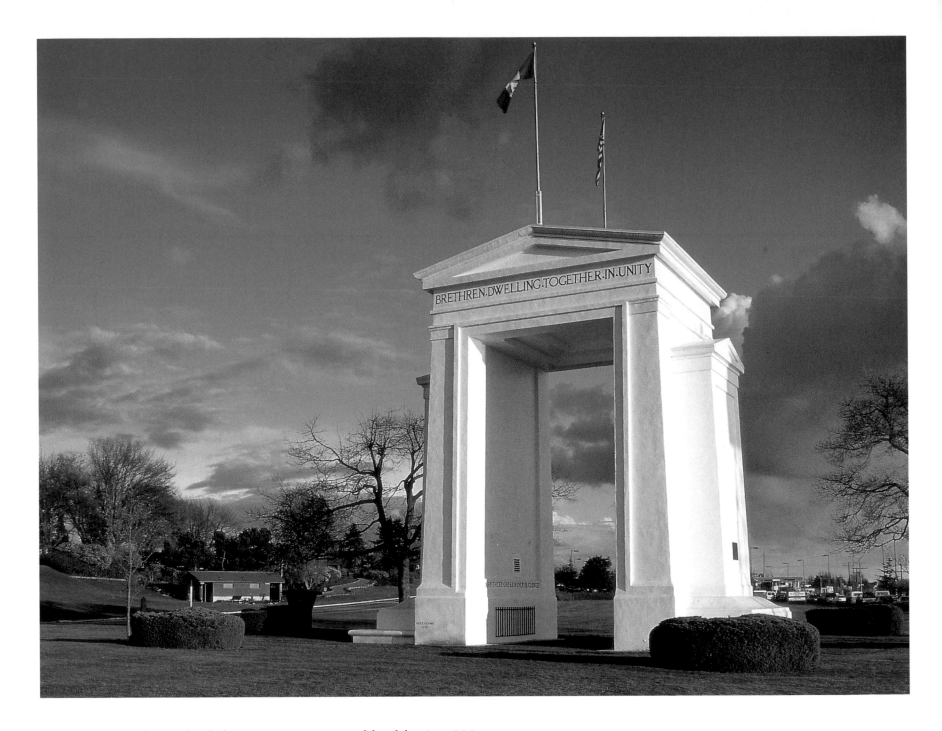

The Peace Arch was built by an American road builder in 1920 to commemorate peace between the United States and Canada. The arch stands on international land, with one pedestal in each country. The park surrounding the arch is jointly managed by British Columbia and Washington State.

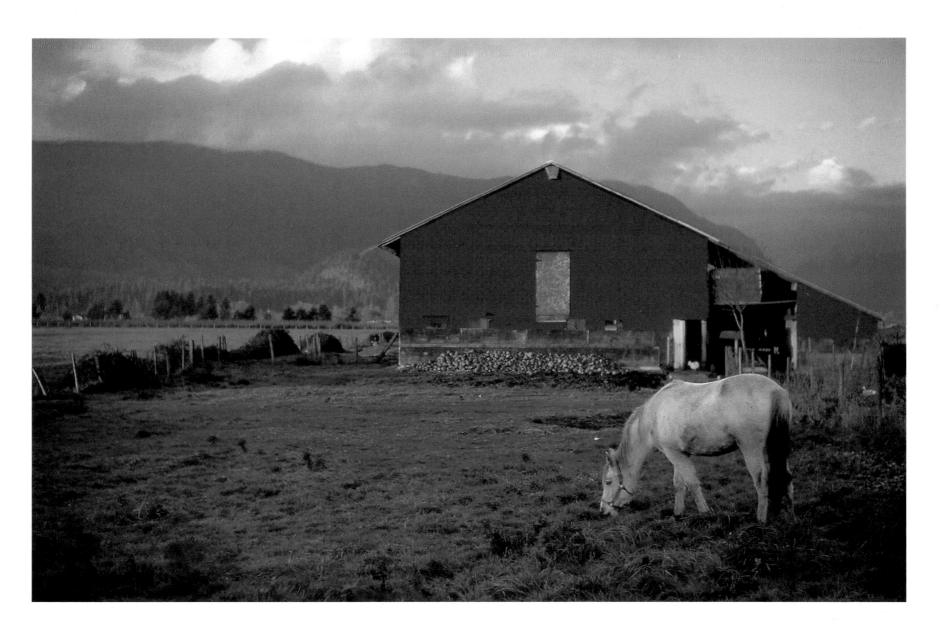

Rich with the silt deposits of the Fraser River, the fertile Fraser Valley is a patchwork of farms and fields only an hour's drive from the bustle of Vancouver.

OVERLEAF –
The Coast Mountains rise above
one of the dykes in Pitt Meadows.

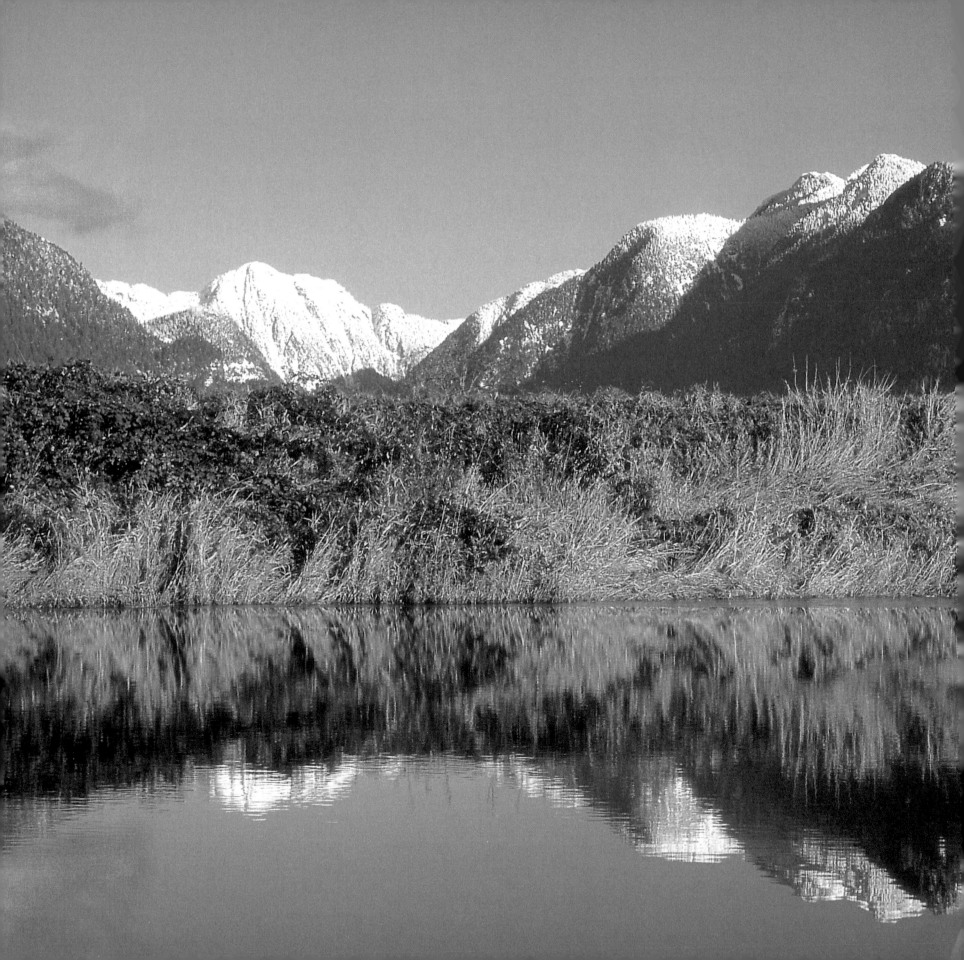

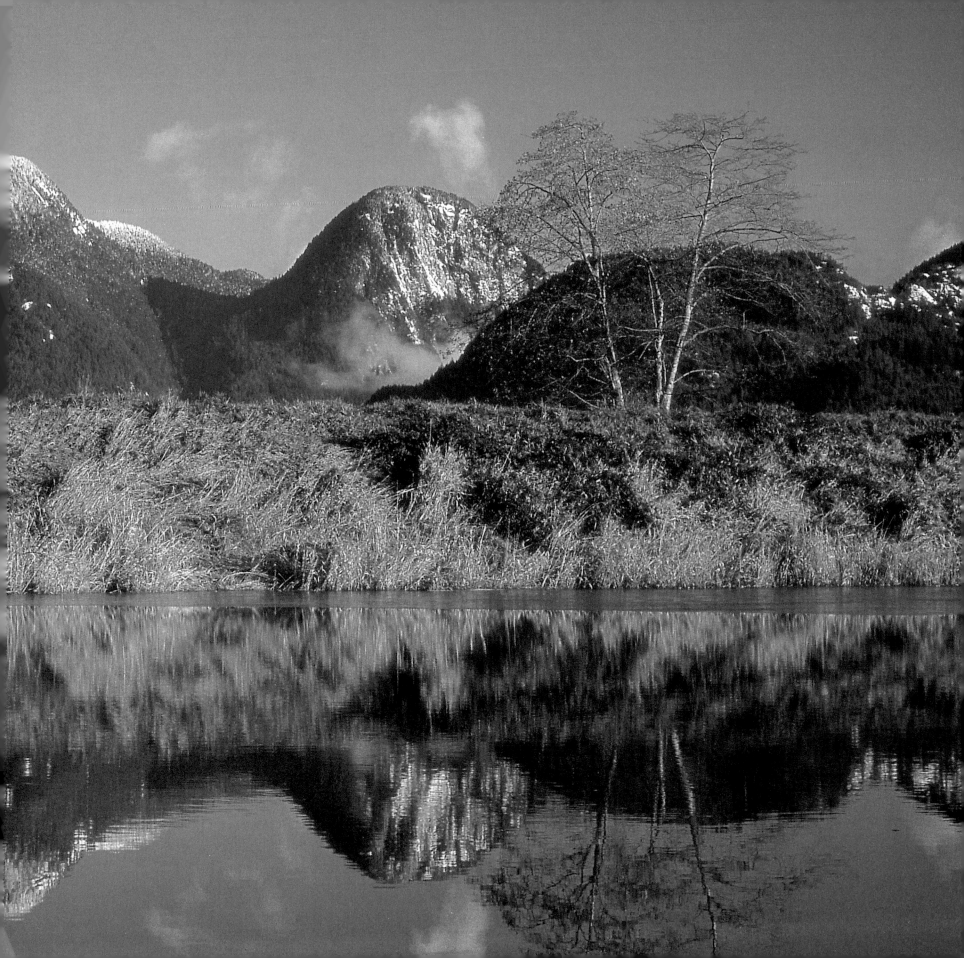

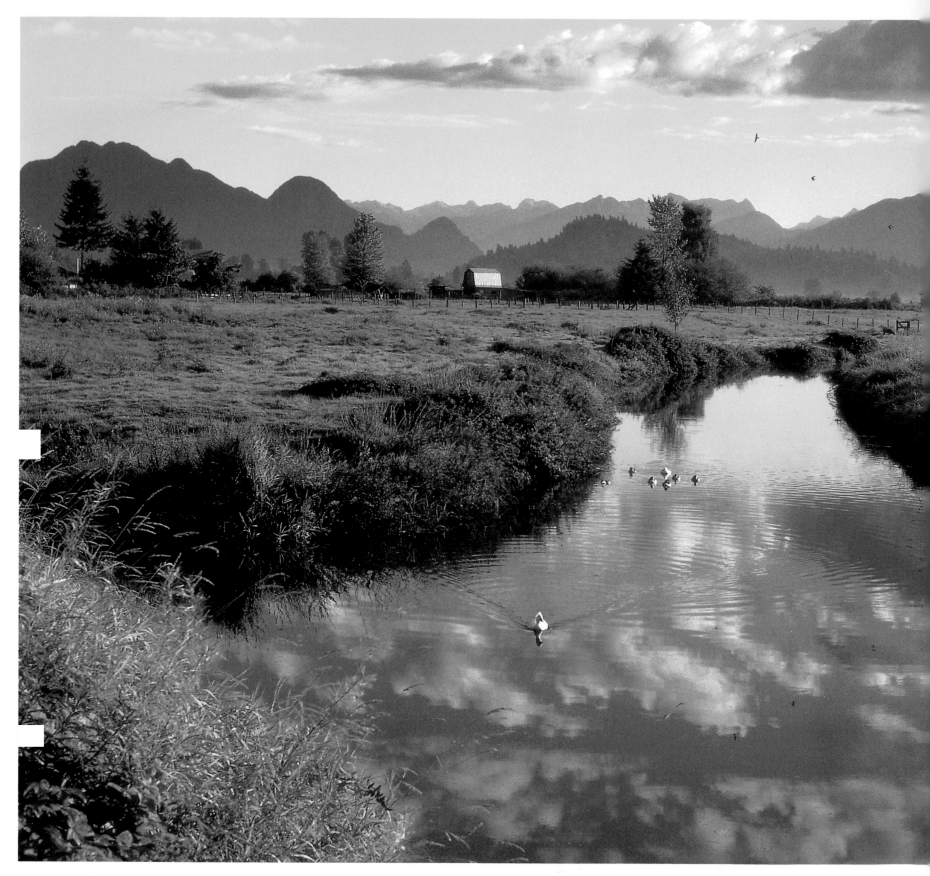

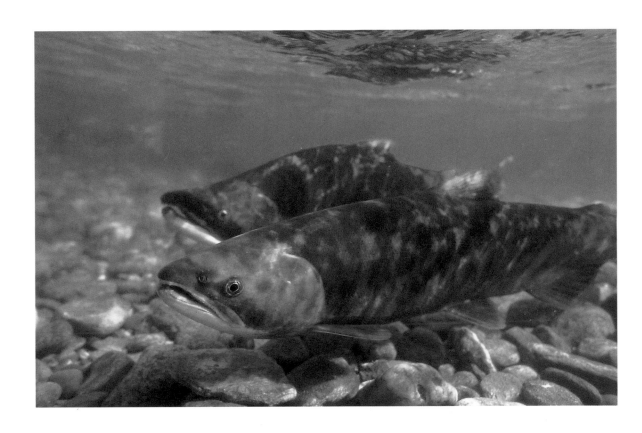

Swimming towards home, scarlet sockeye salmon head for their spawning grounds. One of the best places to see this migration is along the Adams River, near Shuswap Lake. Fry spend a year in the lake before retracing their parents' route to the Pacific.

Dykes and canals protect the farmland of the Fraser Valley, which supplies the province with much of its produce and berries.

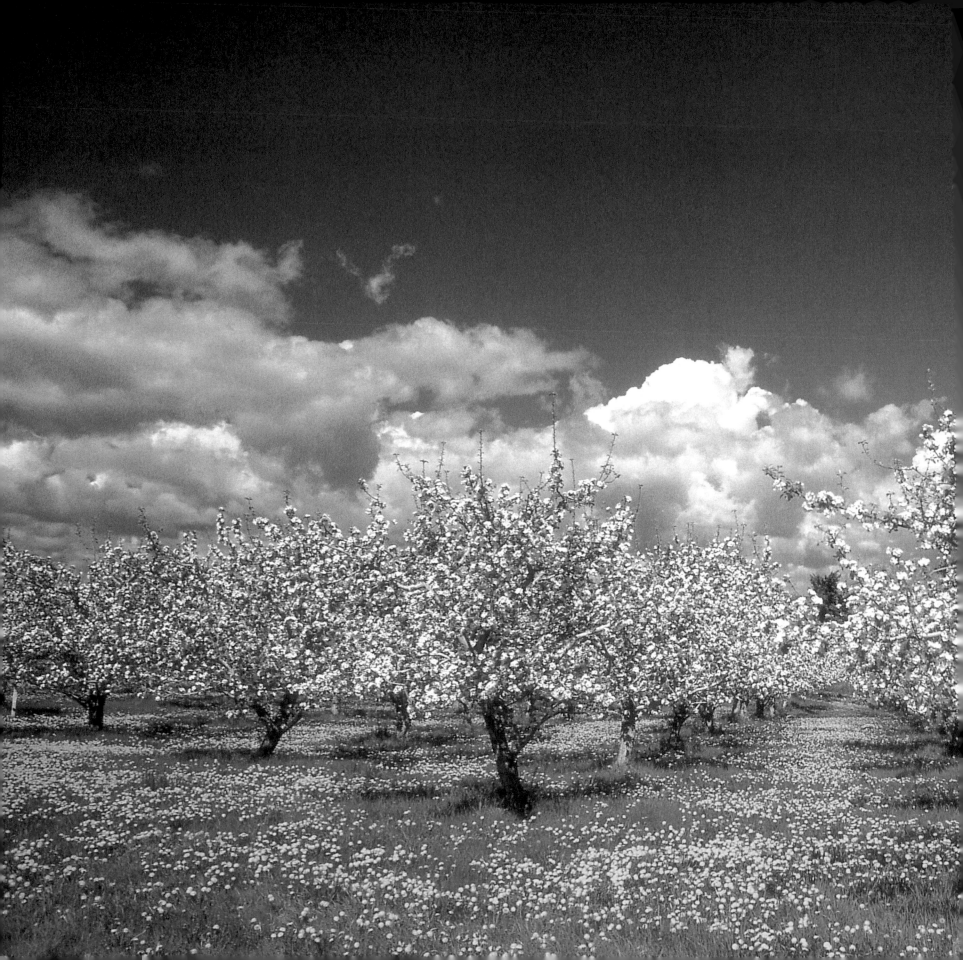

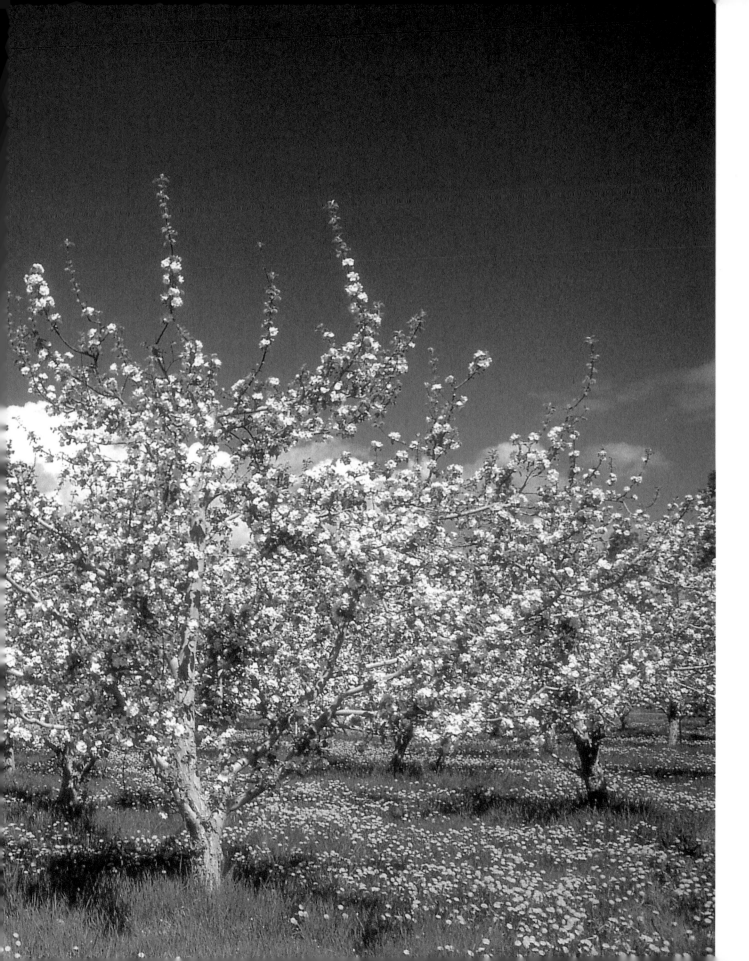

Okanagan orchards keep the province and the world supplied with apples, cherries, peaches, plums, and pears. There are 2000 fruit tree growers in B.C. Most live in the Okanagan, Similkameen, and Creston valleys. Fruit from these areas is sold in more than 30 countries and earns about $35 million a year in export sales.

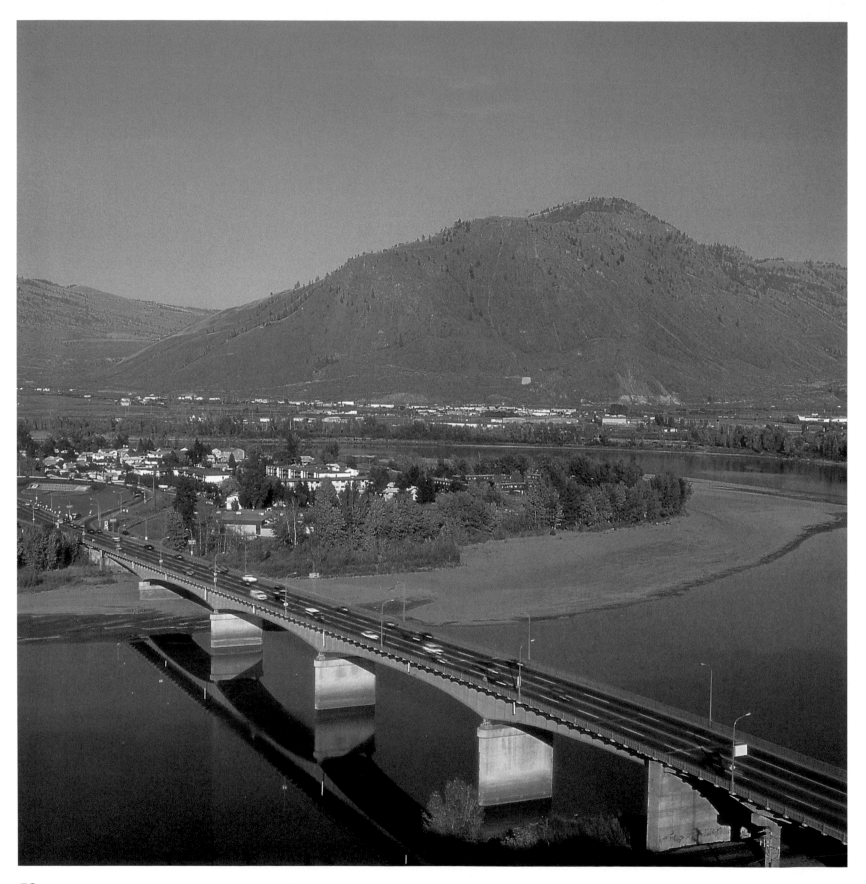

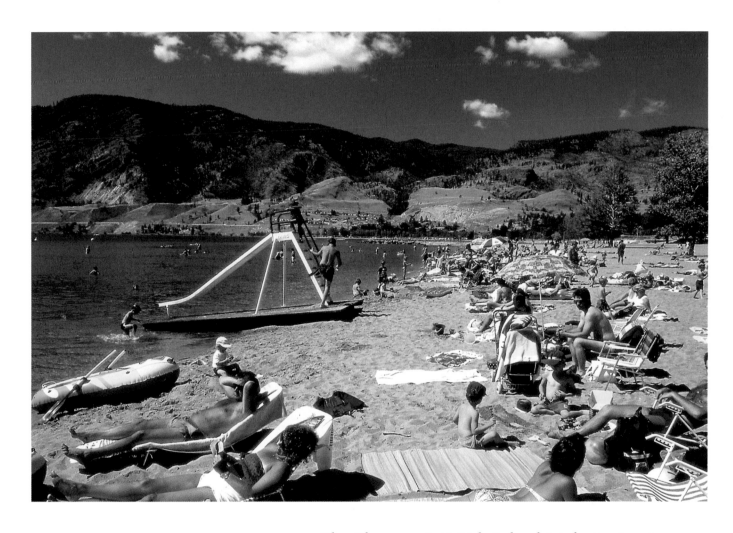

The Okanagan is British Columbia's hottest region, and these Skaha Lake swimmers and sunbathers obviously appreciate the sunshine.

Once a major fur-trading post, the city of Kamloops is now a ranching and industrial centre.

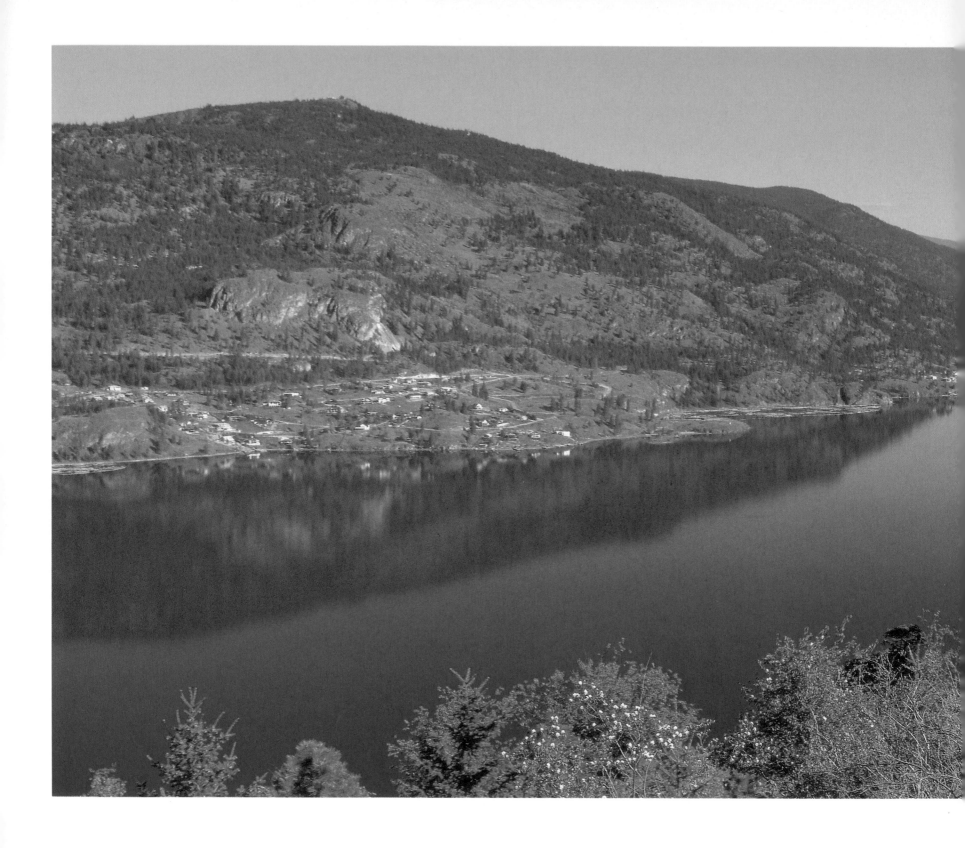

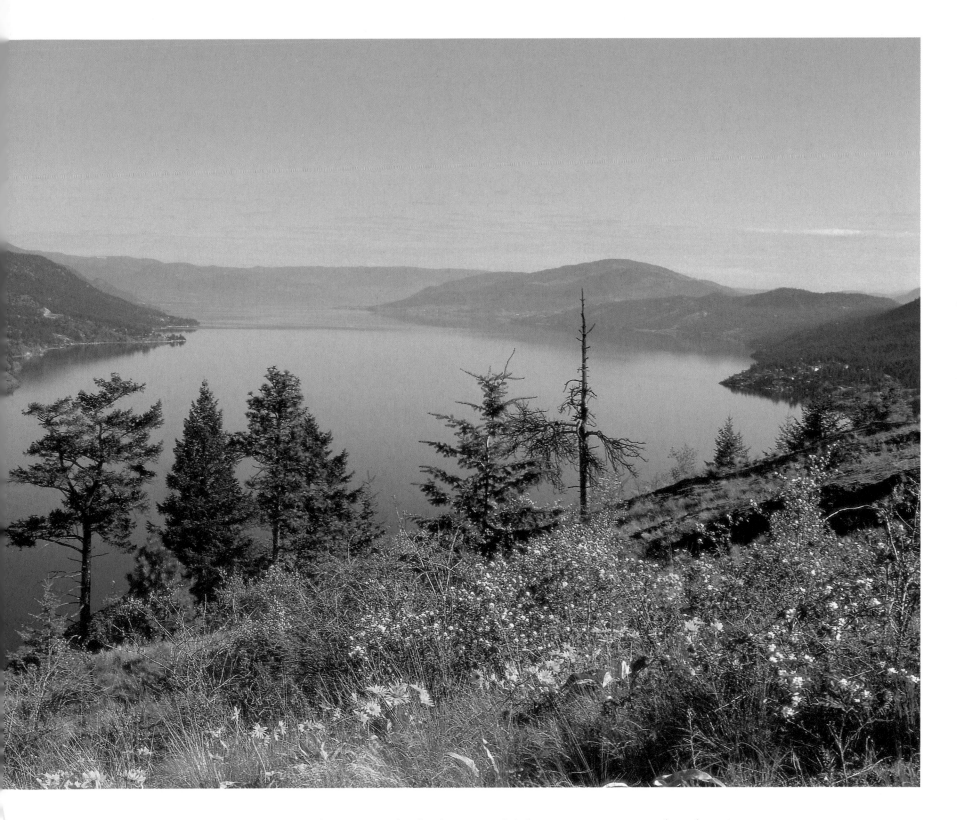

From Knox Mountain near Kelowna, Okanagan Lake looks peaceful, but it's a very popular place in summer.
Even the legendary Ogopogo lake monster can't keep vacationers away from the warm waters and sandy beaches.

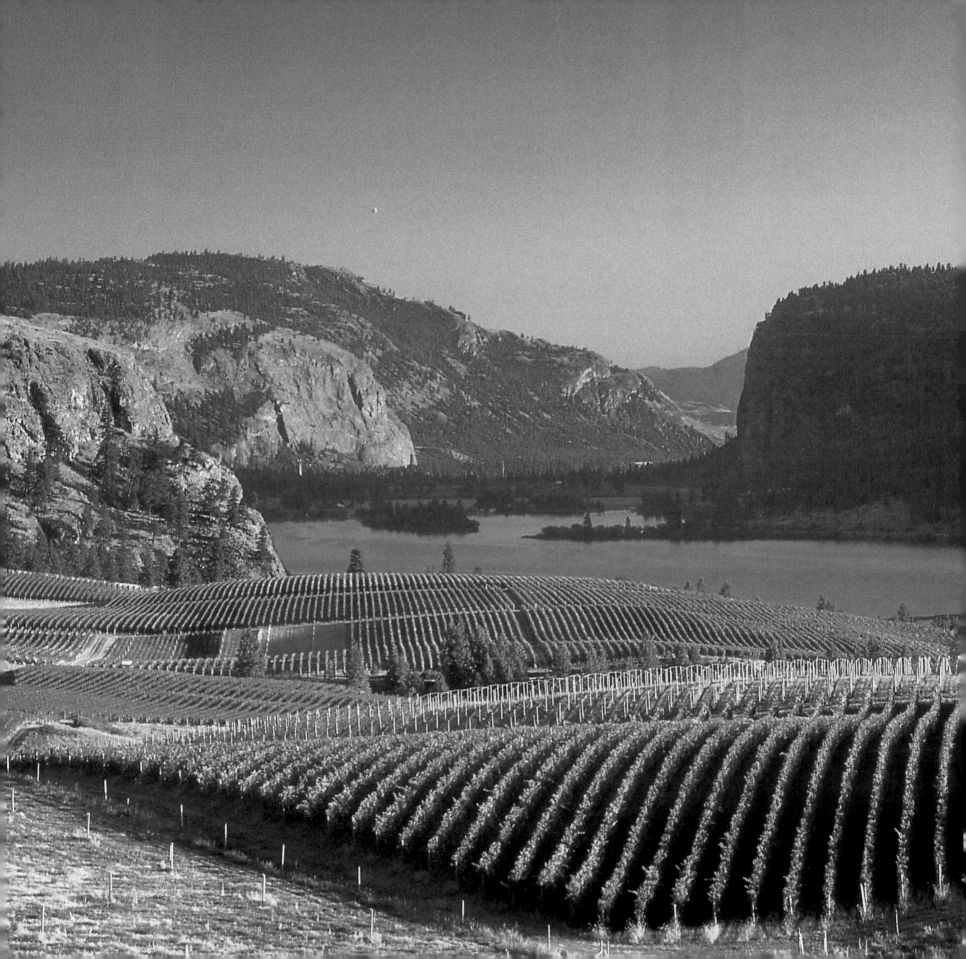

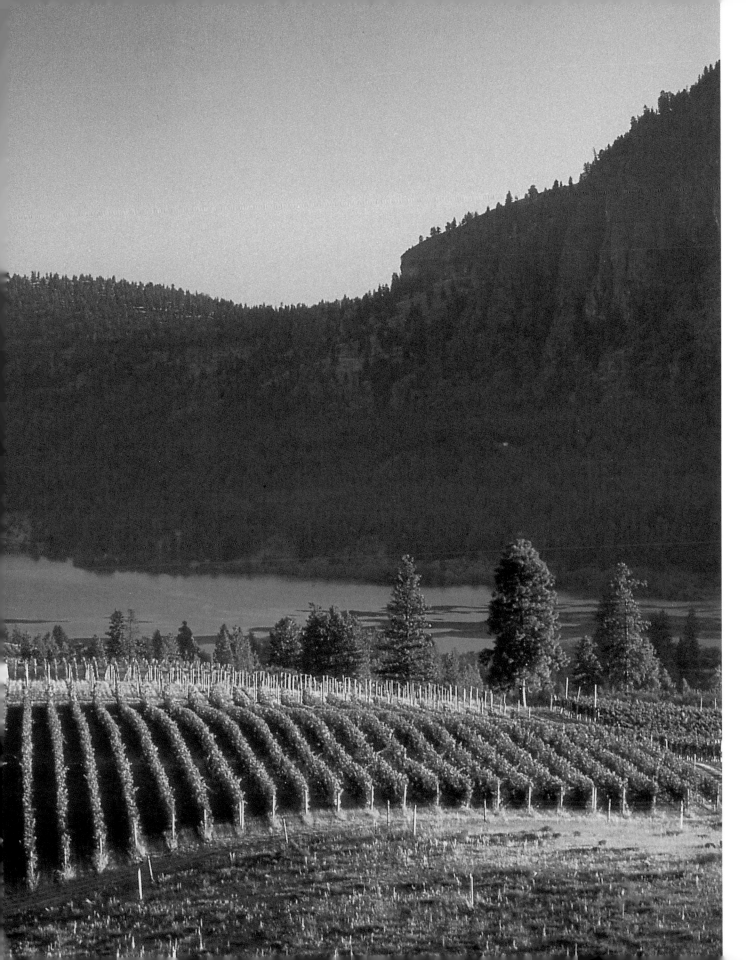

Blue Mountain Vineyard is one of many that takes advantage of the Okanagan's hot, dry summers. In the background lies Vaseux Lake, a bird and wildlife sanctuary that attracts trumpeter swans and Canada geese, among other species.

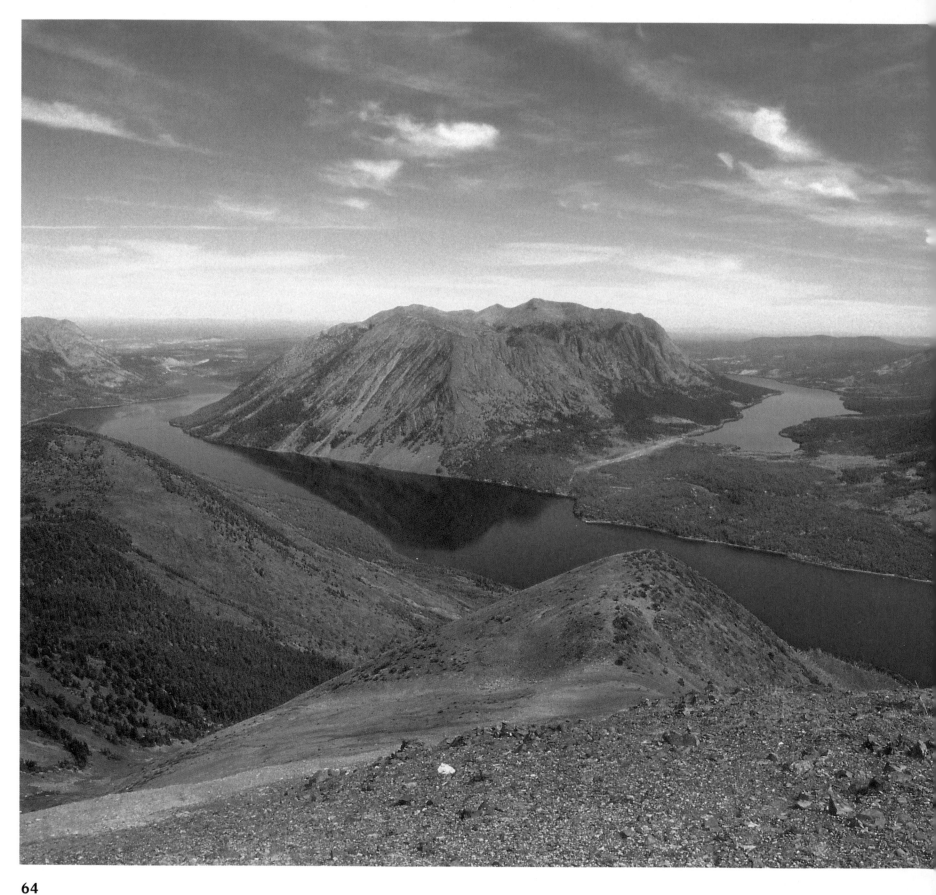

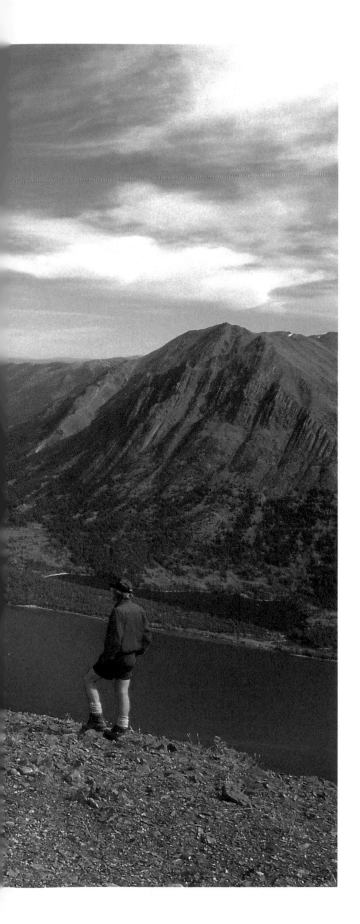

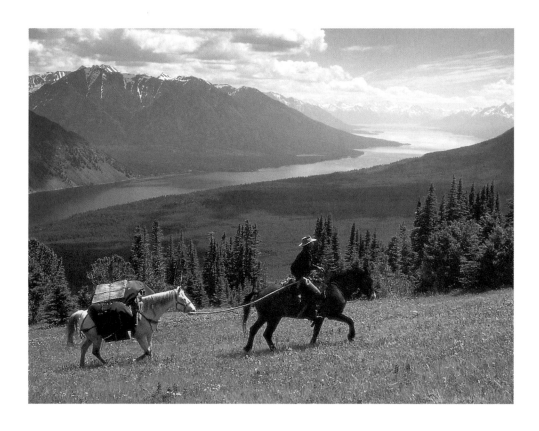

Ts'yl-os Provincial Park was created in 1994 through a partnership between the B.C. government and area First Nations. The combination of strong winds and low rainfall make the land unique. The park is known for interesting rock formations and rare plants, as well as its ample hiking and fishing opportunities.

From one of the highest peaks in the Coast Mountain range, a hiker looks down on Chilko and Tsuniah lakes. The area is a favourite with canoeists and anglers, but high winds and sudden storms make it necessary to stay alert.

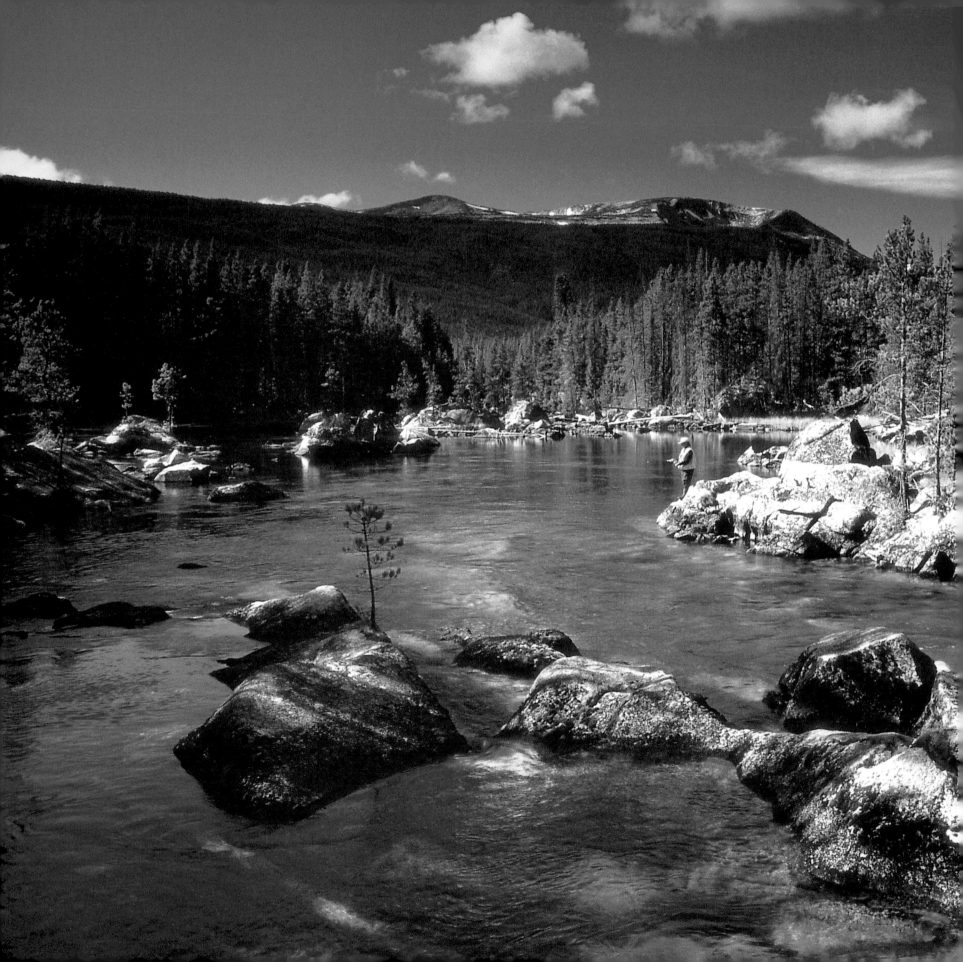

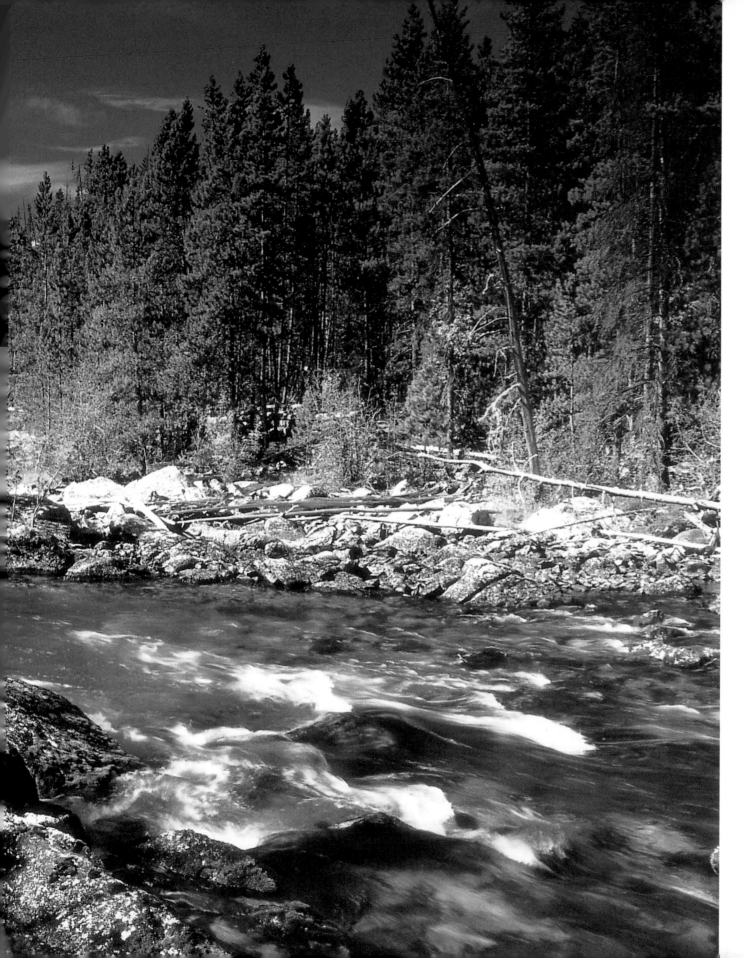

The area surrounding Nimpo Lake in the Chilcotin region is an angler's heaven. Not only are there many prime sites nearby, but float planes transport people to more remote fly-fishing locations.

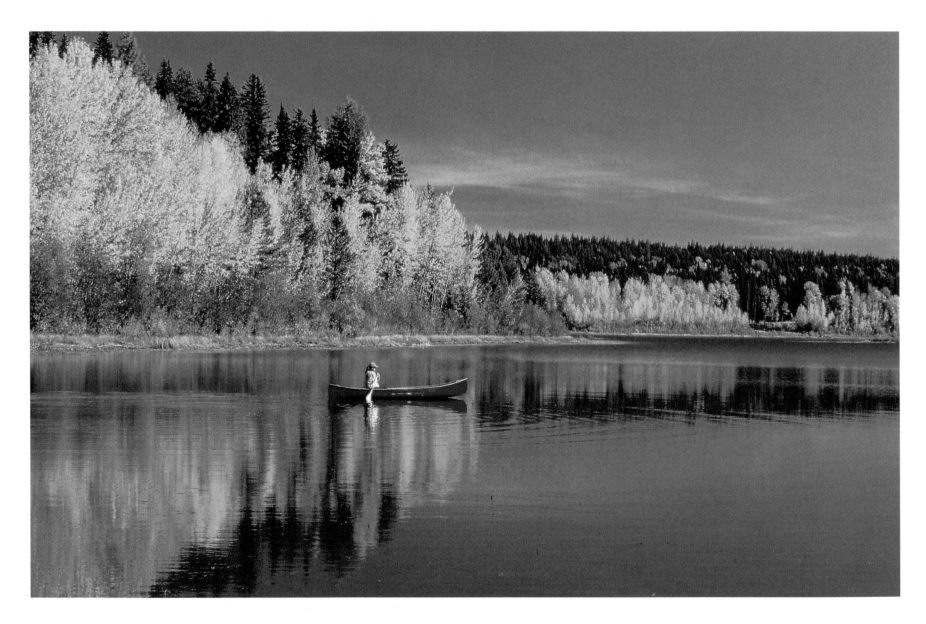

A canoeist enjoys a tranquil moment on Cariboo Lake.

Whitewater rafting trips through the Thompson River's rapids make the nearby town of Lytton a base for adventure seekers. The trips are said to be completely safe, but the names of the rapids—Jaws of Death and Devil's Kitchen—reveal the reactions of earlier, less well-equipped travellers.

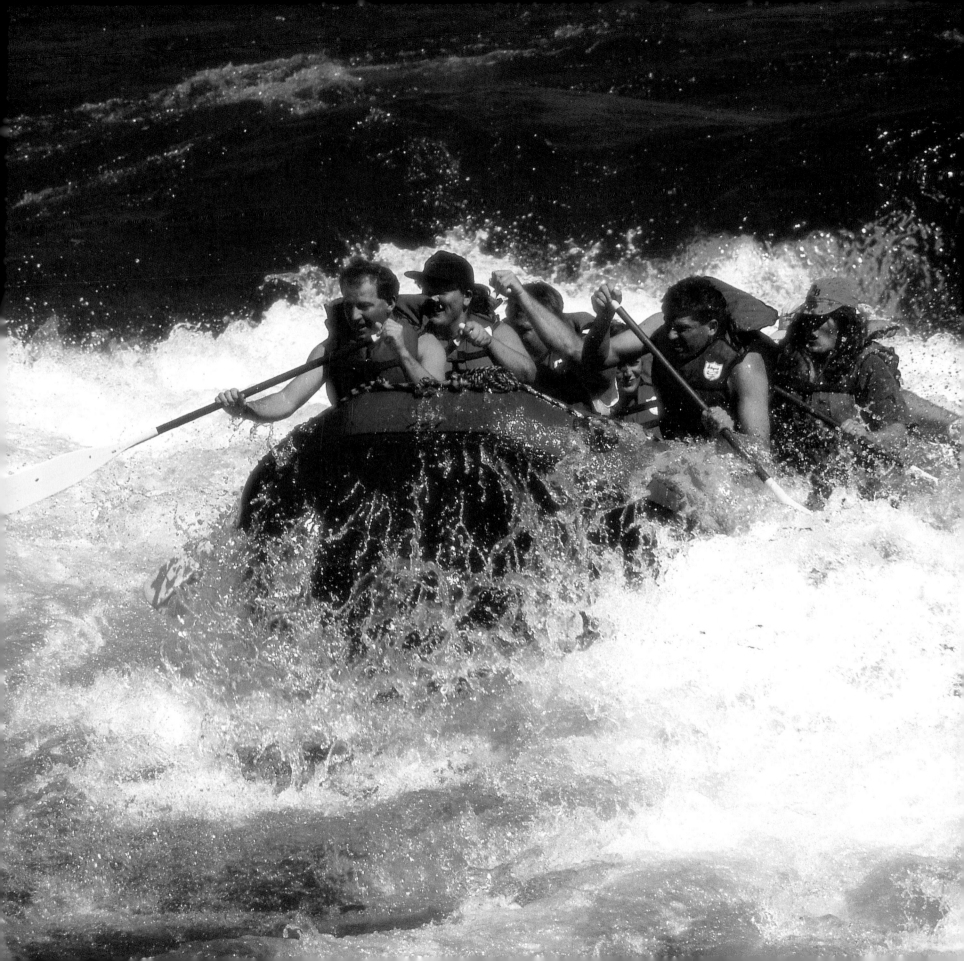

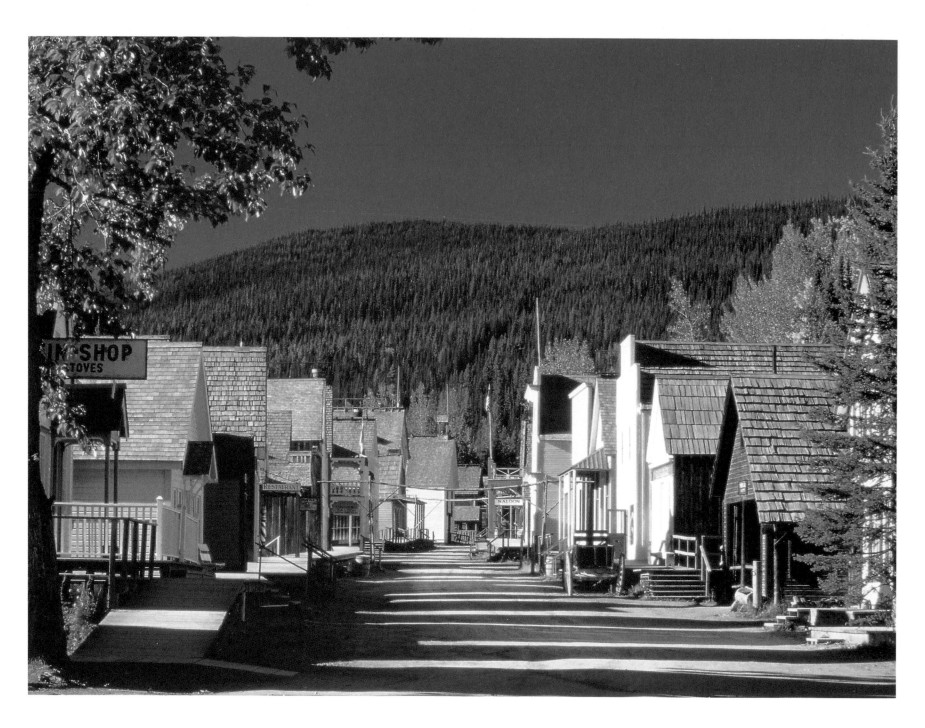

Barkerville was once a Cariboo gold rush boomtown.
Now the site is a provincial park where visitors can
tour restored buildings or pan for gold.

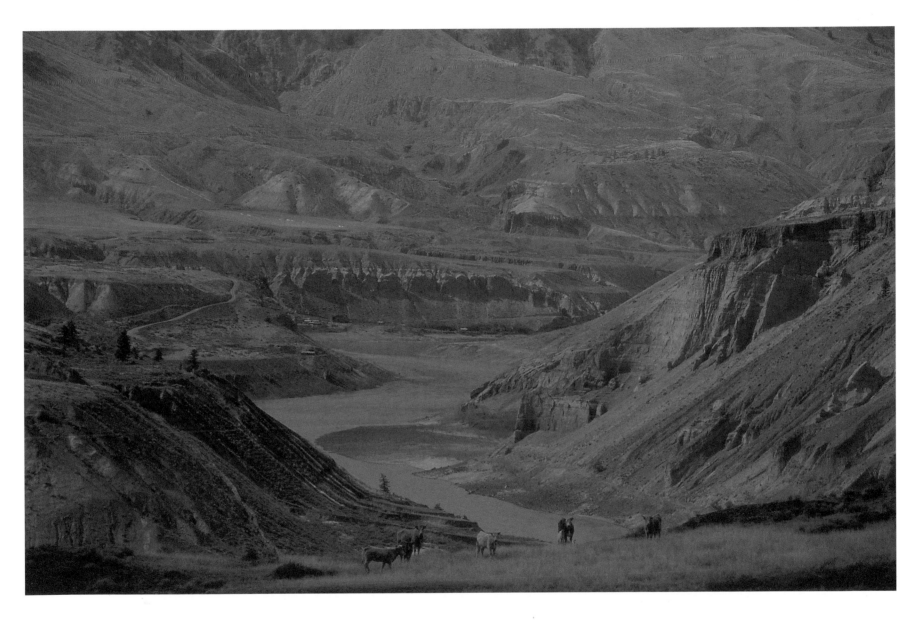

A large part of B.C.'s rangeland is in the Cariboo region, where enormous cattle ranches stretch among the hills.

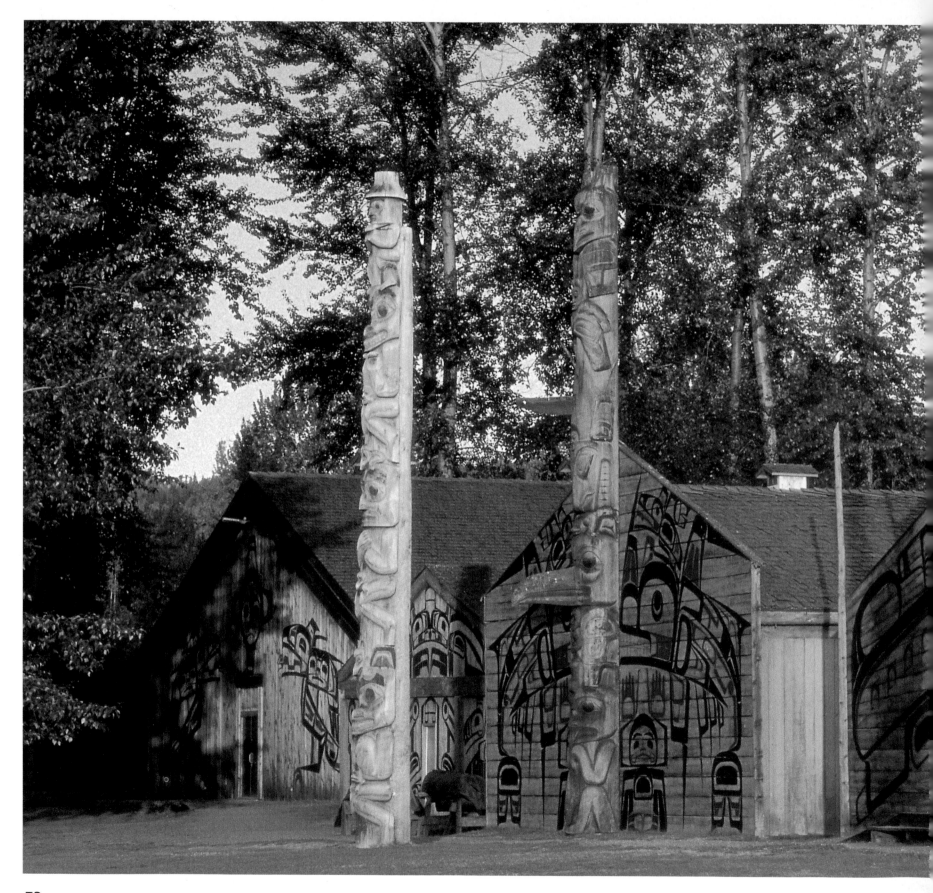

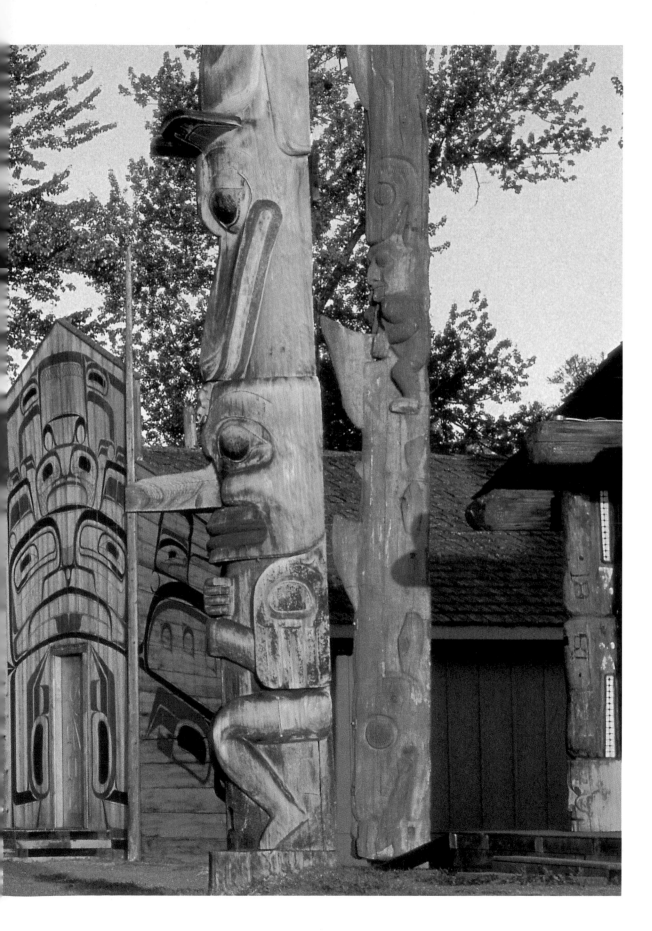

A carving school and historical site at the 'Ksan Village in Hazelton ensure that First Nations culture remains strong. First Nations people have lived in the area for more than 7000 years.

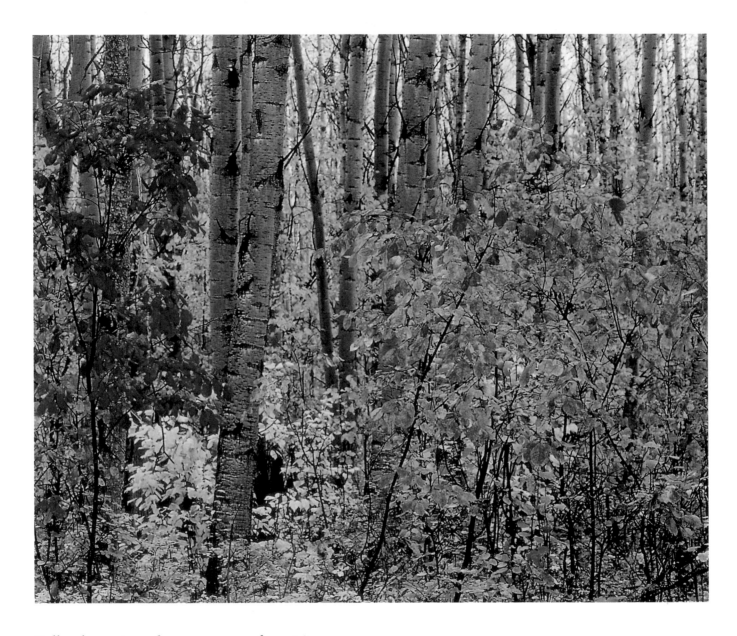

Fall colours transform an aspen forest in
the Peace River Valley.

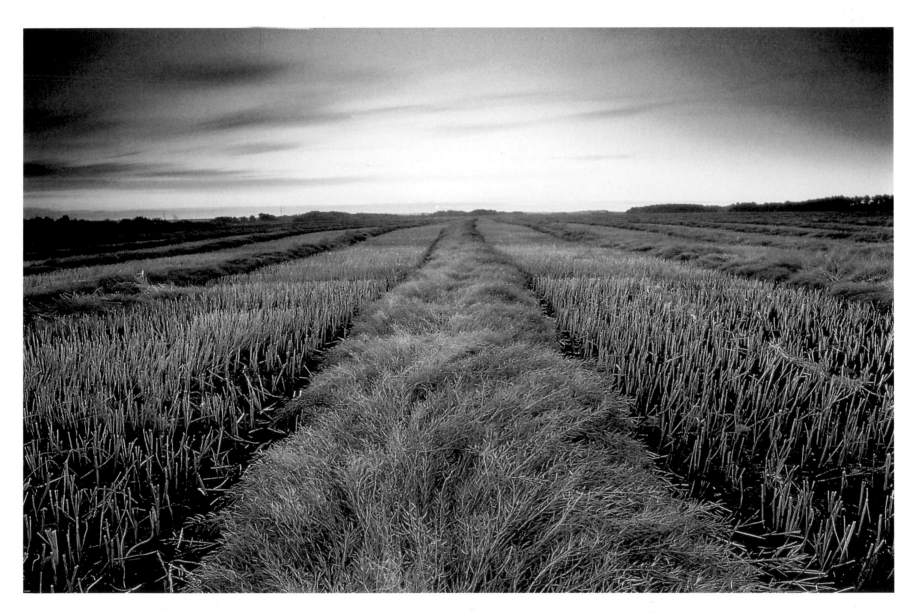

Rows of canola stretch to the horizon in the Peace River region.

OVERLEAF –
Near Dease Lake in northern B.C., Mount Edziza Provincial Park offers a unique volcanic landscape, complete with obsidian. This hard, glass-like rock was once used by area First Nations to make tools. The land is isolated and rugged; an experienced hiker needs about two weeks to cross the park.

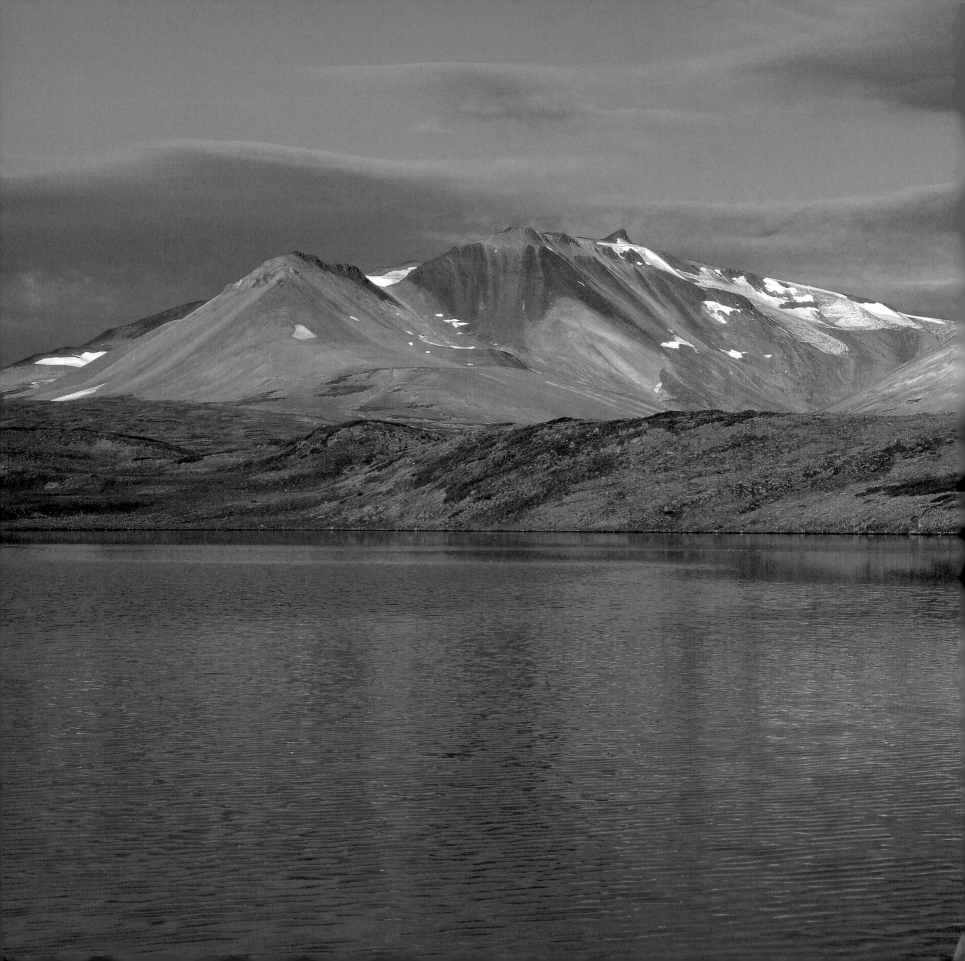

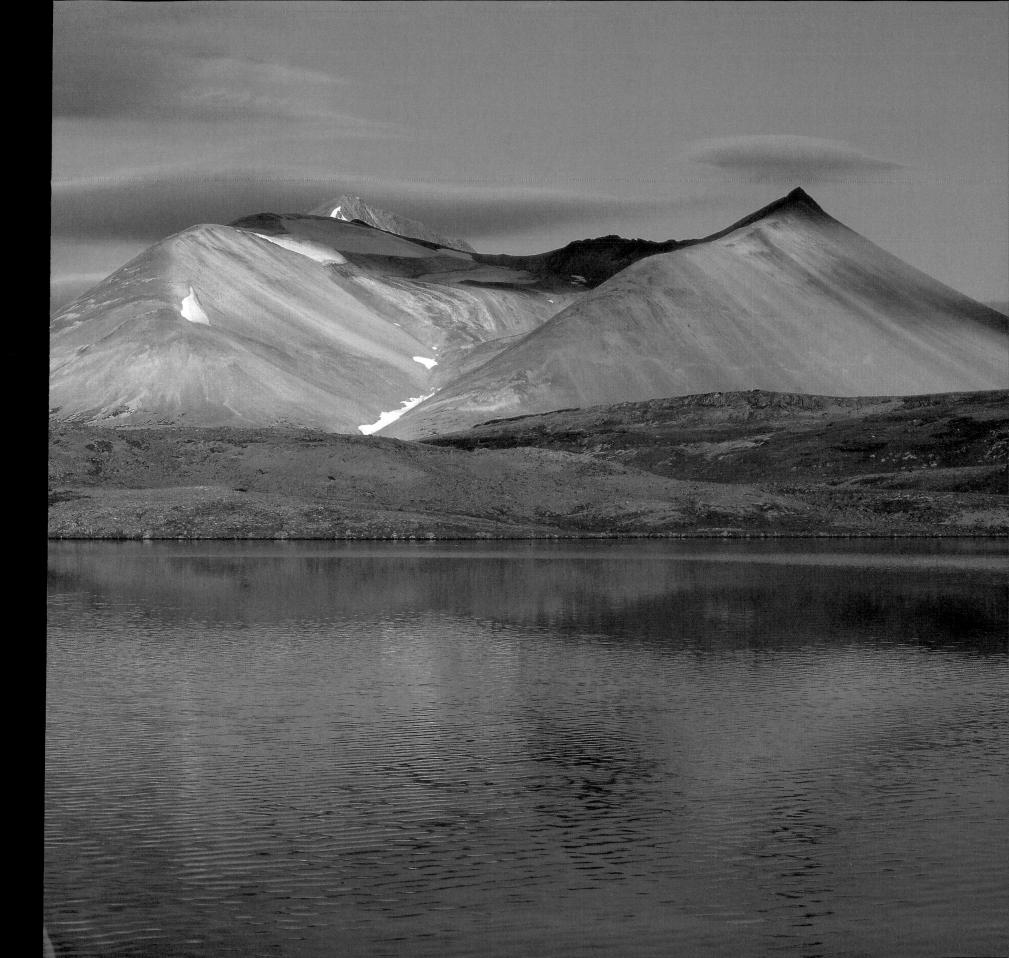

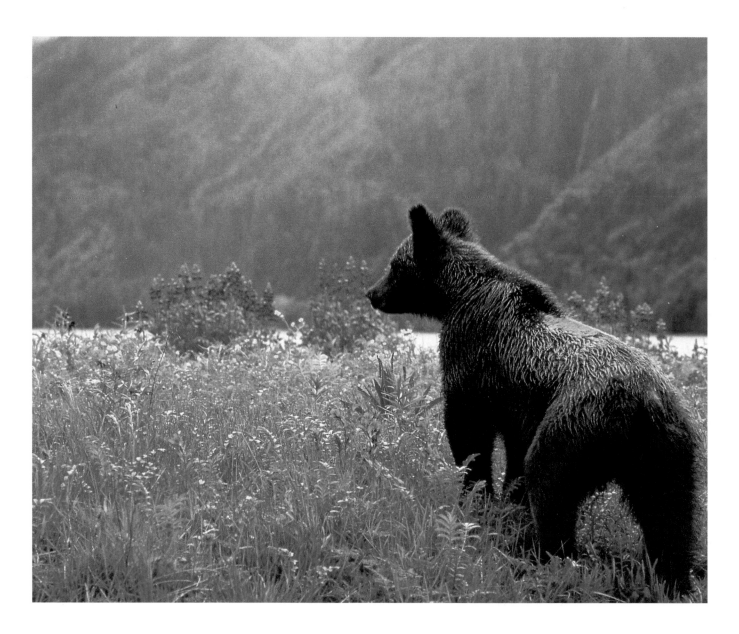

Khutzeymateen is a native word meaning "a confined place for salmon and bears." The area is a protected grizzly sanctuary and thousands of bears gather each fall to feast on the migrating salmon.

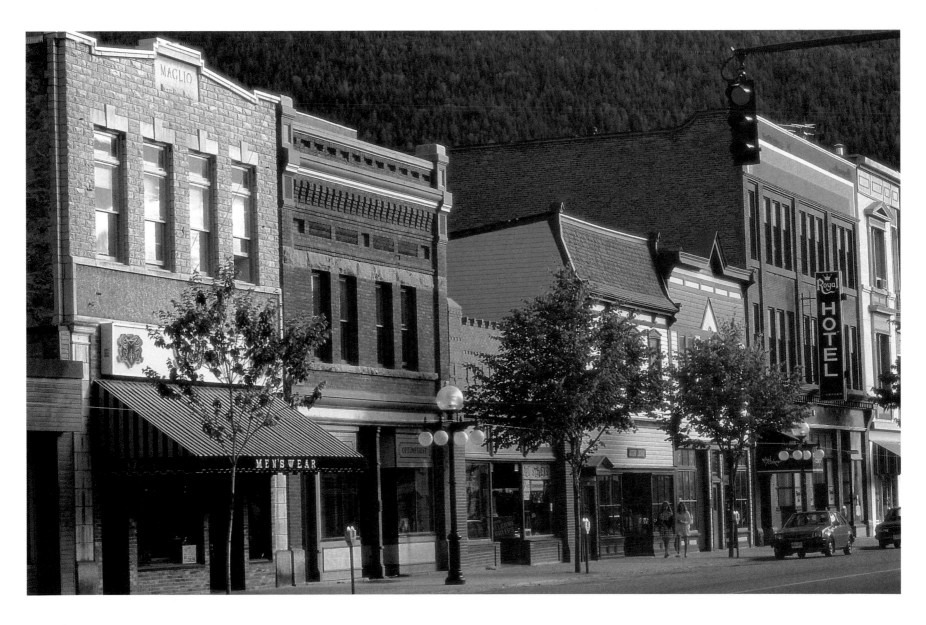

Artisans' shops and art galleries line Nelson's Baker Street, in the West Kootenays. Many of the historic storefronts have recently been restored.

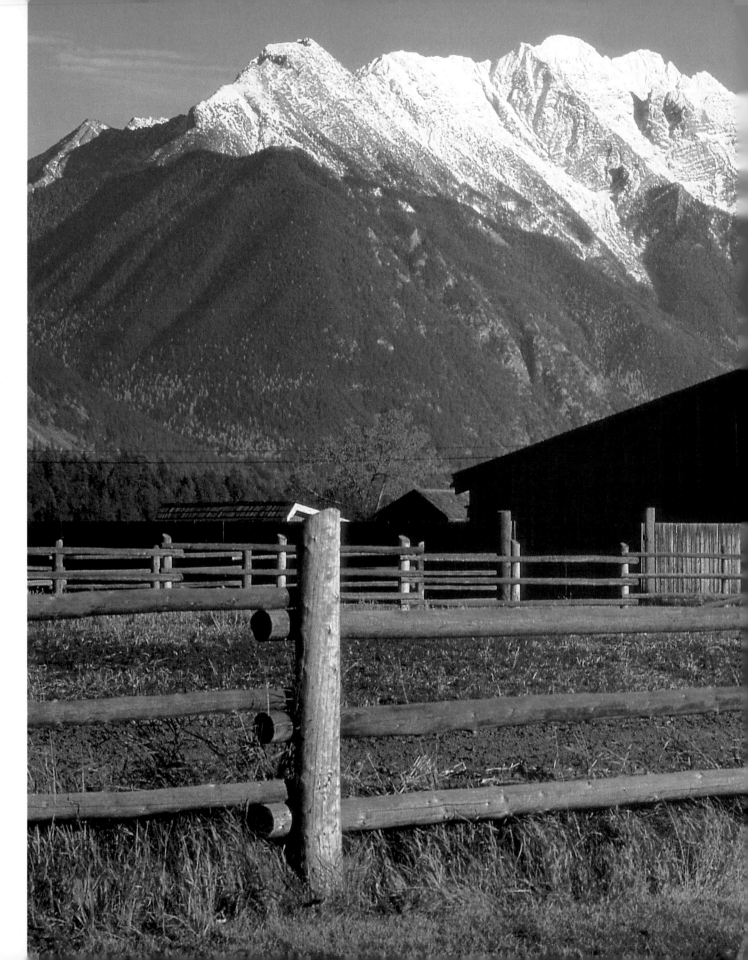

Visitors to historic Fort Steele can enjoy live vaudeville shows at the Wild Horse Theatre and buy stick candy at the General Store. The town was once a gateway to the Wild Horse Creek gold rush and was named after a famous gold rush law enforcer, North West Mounted Police Superintendent Sam Steele.

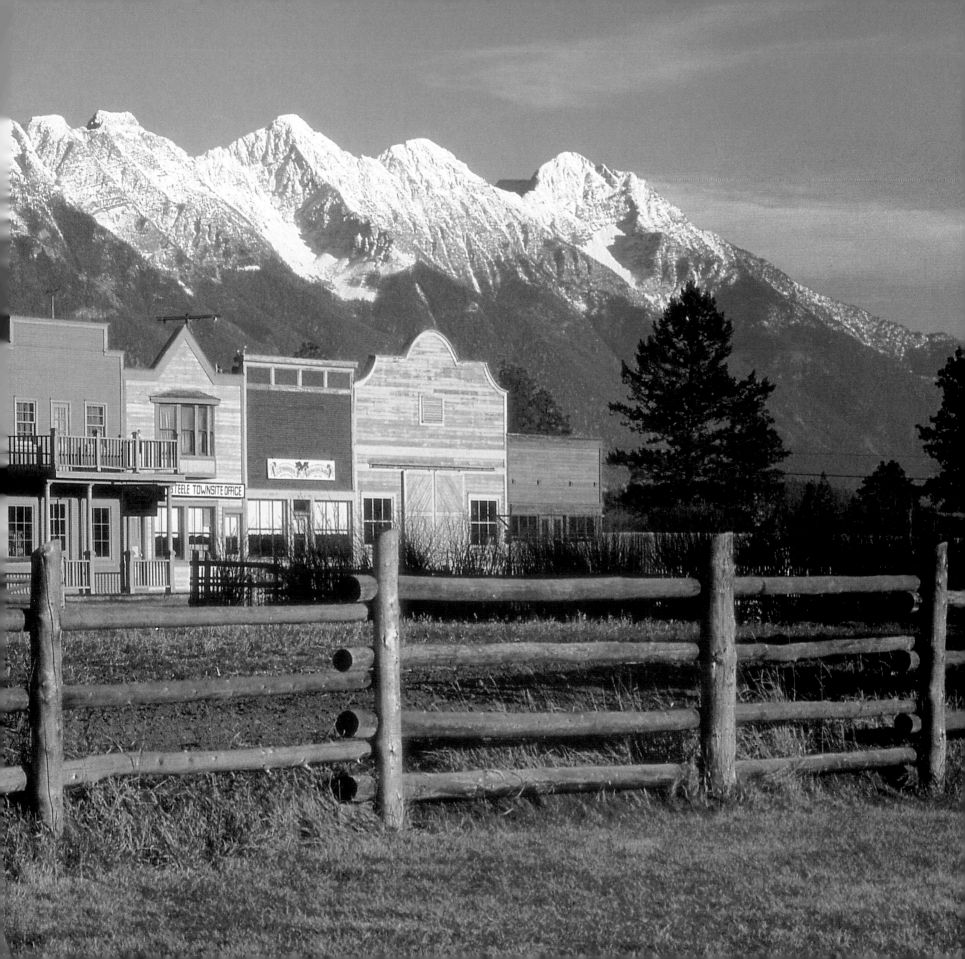

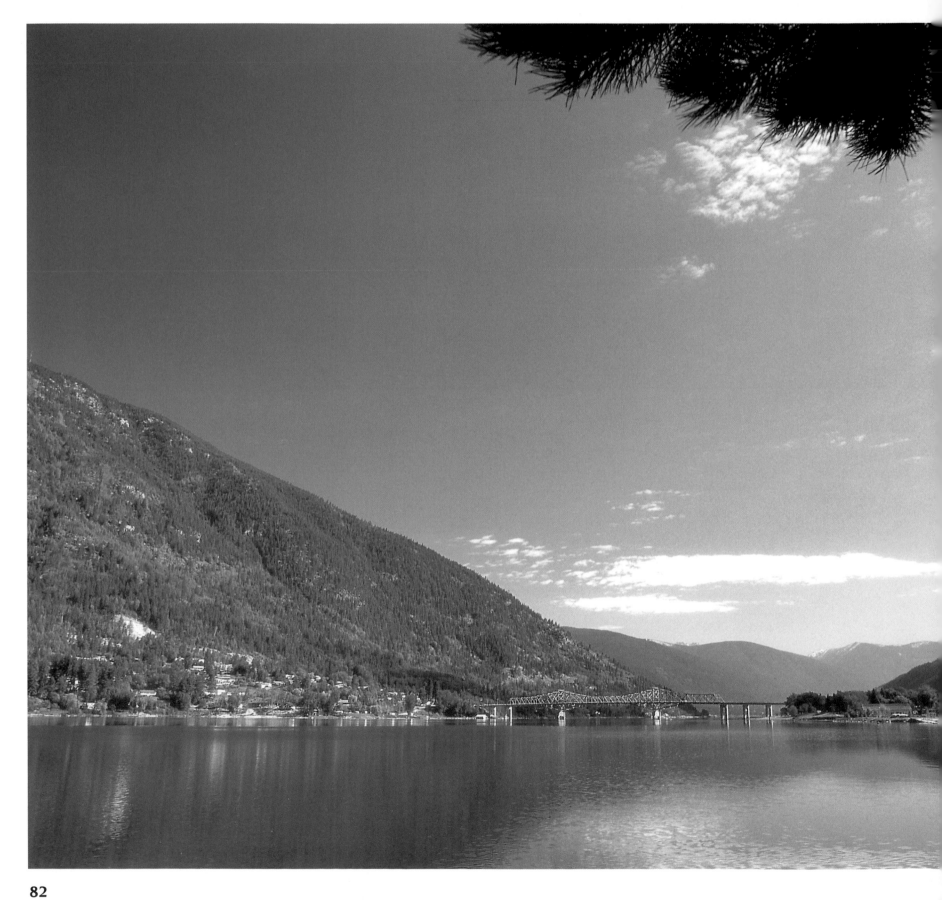

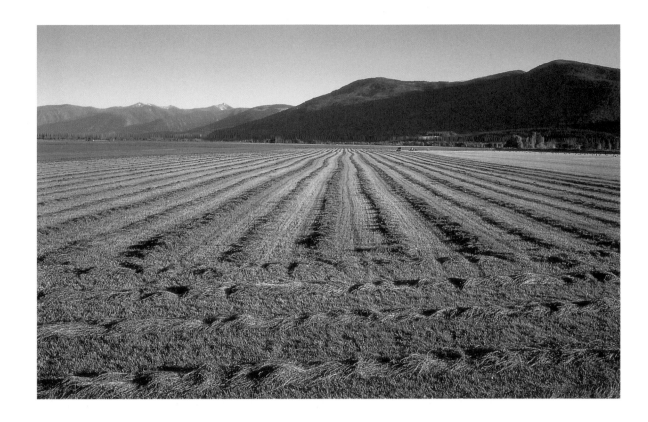

The Creston Valley flats were once flooded each year by the Kootenay River. Dykes built between the 1890s and 1930s controlled the flooding and opened the rich land to alfalfa, corn, potato, and canola fields. This is the largest agricultural area in the Kootenay region.

The city of Nelson lies along the protected west arm of Kootenay Lake. Because water from the many mountain creeks moves quickly through the lake and towards the Columbia River, the water is especially clean and cold. Boaters enjoy the lake year-round, but swimmers don't venture in until July.

OVERLEAF –
Bugaboo Glacier Park includes the largest icefields in the Purcell Mountain Range. Many of the mountains here tower to more than 3000 metres (9840 feet).

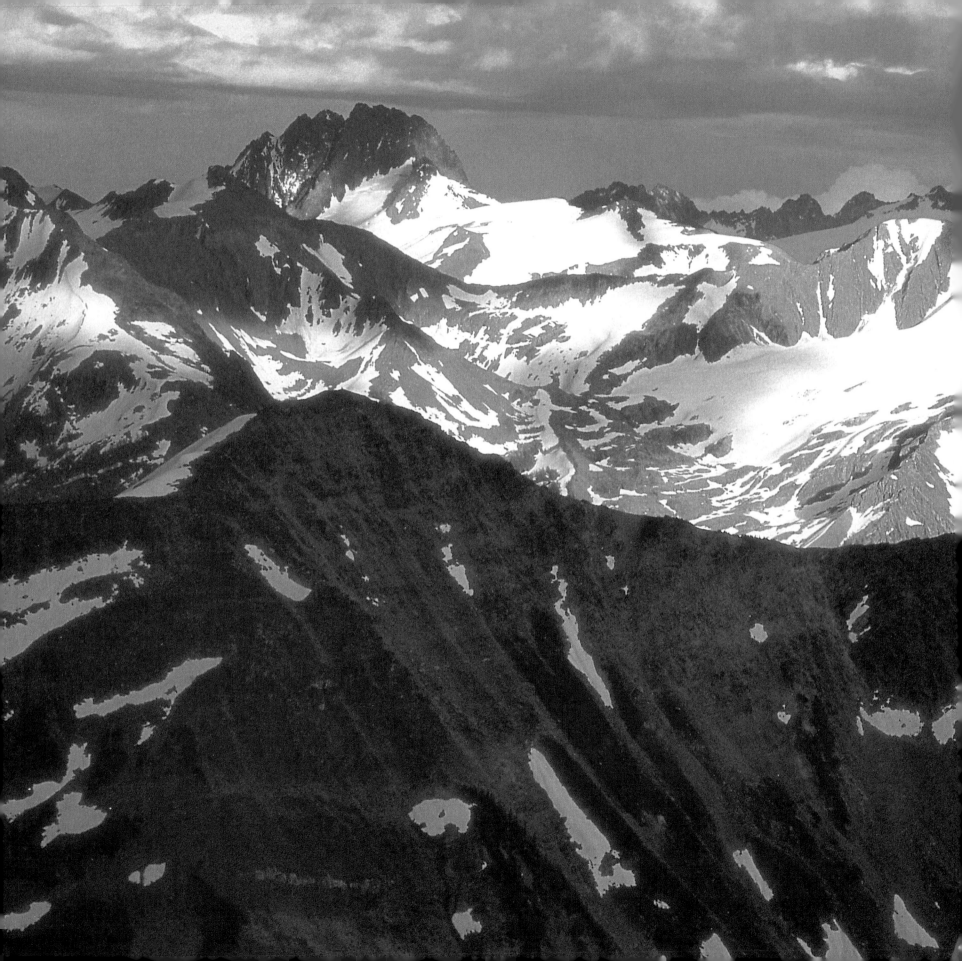

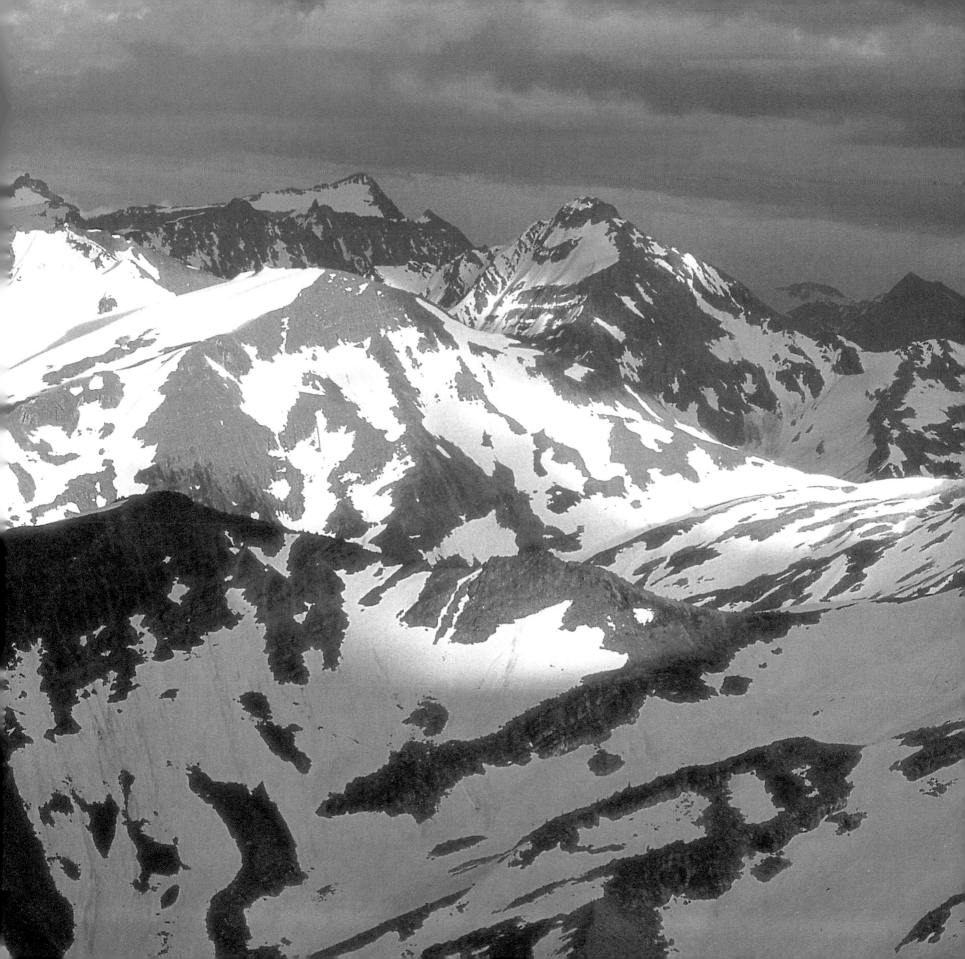

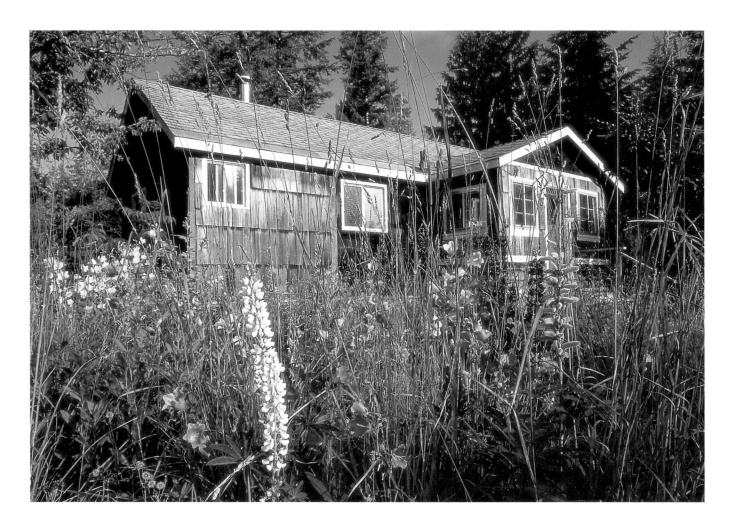

During World War II, 13,000 Japanese Canadians were wrongly suspected of threatening national security and forced from their homes along the Pacific. Hundreds of people were interned in New Denver, in small, uninsulated shacks like this one.

Wildflowers cover a meadow in Mount Revelstoke National Park, at the foot of the Rockies.

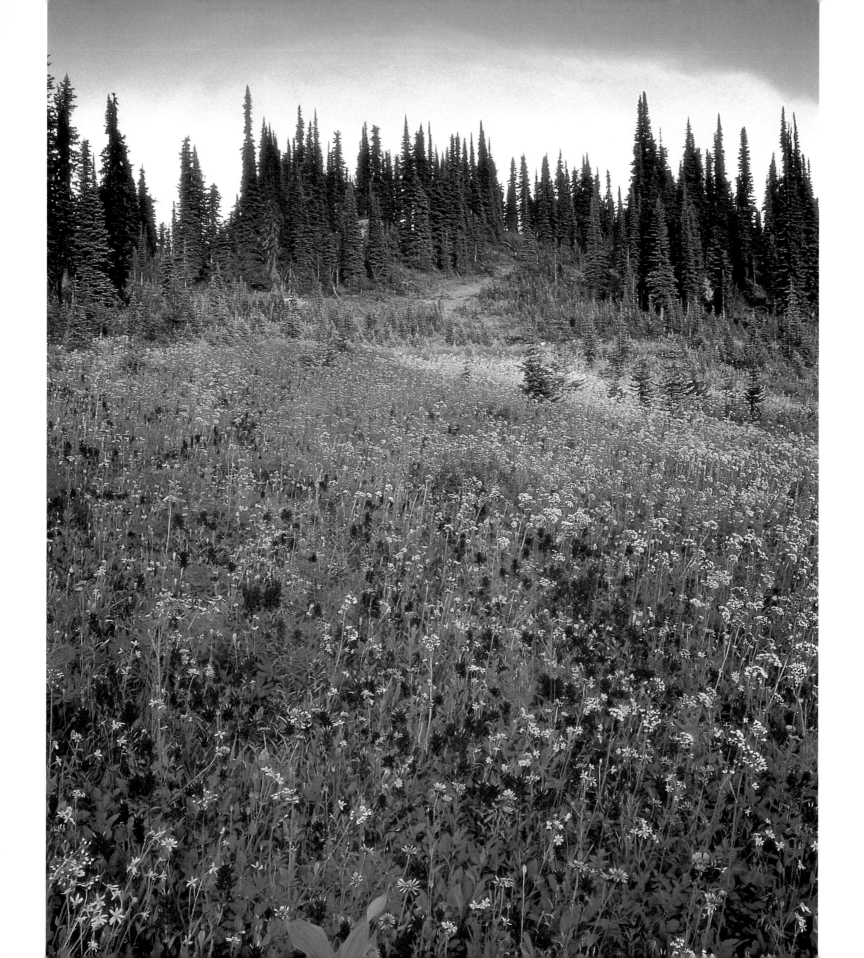

Mount Robson is the highest peak in the Canadian Rockies, and its summit is almost always obscured by cloud. Canada's third largest river, the Fraser, originates here.

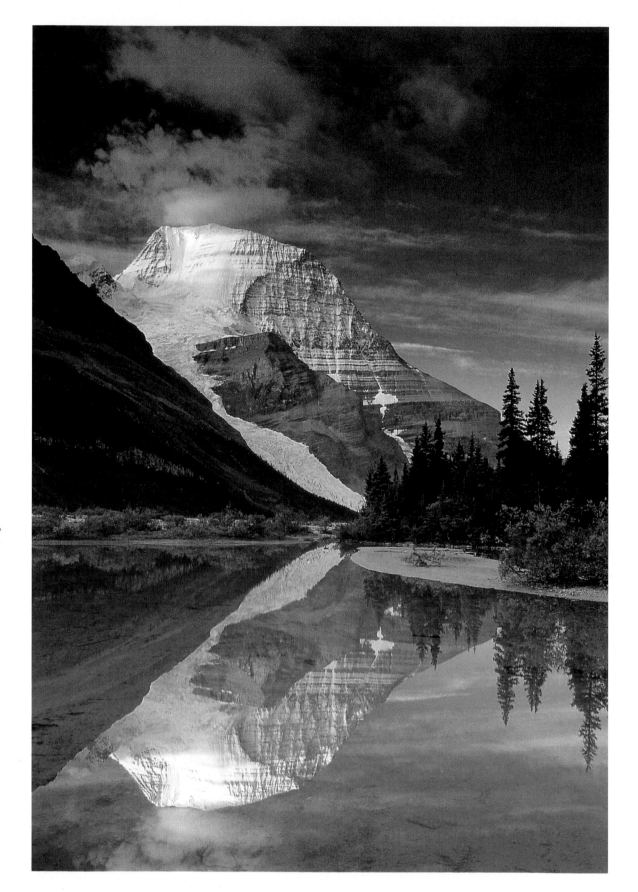

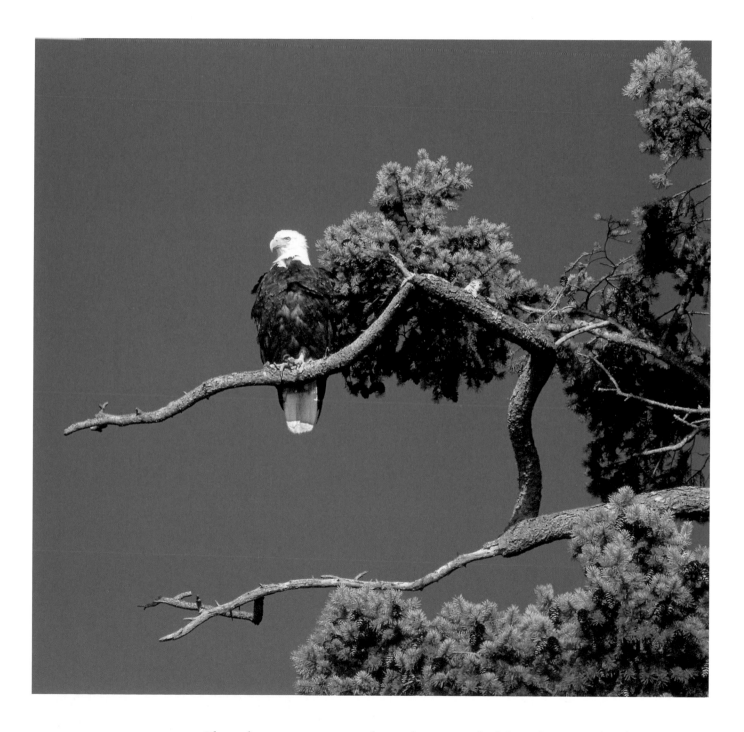

Though most common along the coast, bald eagles can also be spotted circling above the large lakes of the Interior. More than 25 percent of the world's bald eagles live in B.C.

More than 30 hiking trails begin at Lake O'Hara.

Facing Page –
At the peak of the spring run-off, 255 cubic metres a second pour over Wapta Falls into the Kicking Horse River.

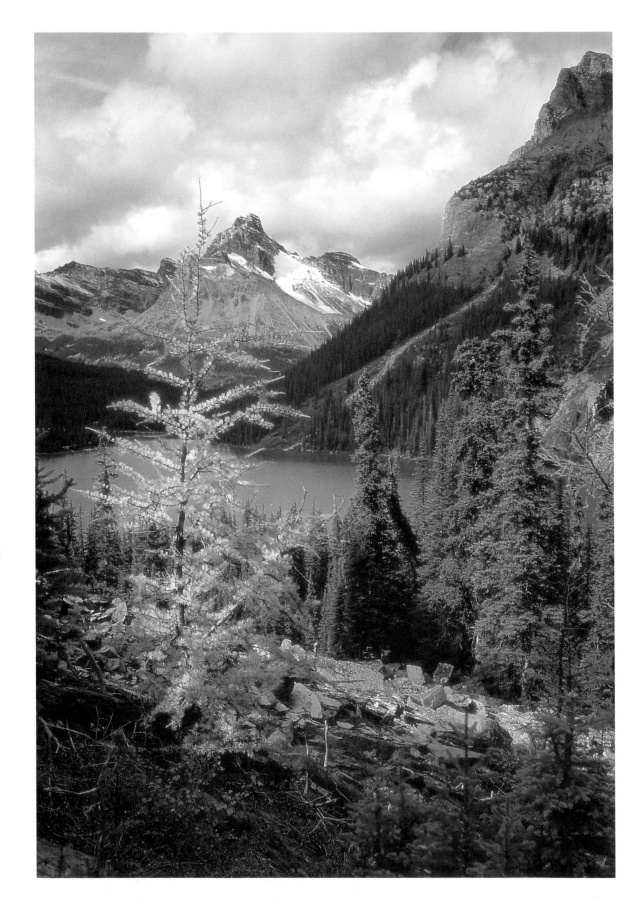

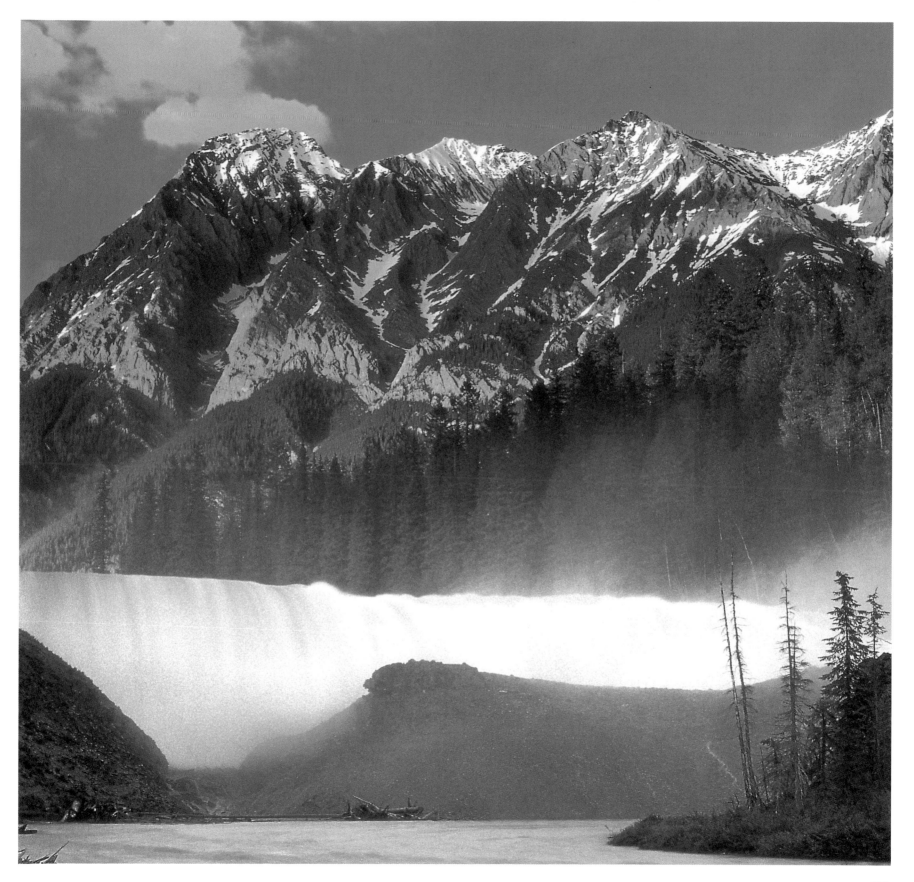

The icy, glacier-fed waters of Emerald Lake are a popular stop along the Trans-Canada Highway.

FACING PAGE –
Glaciers grind tiny particles of silt into the ice. When the ice melts, the particles remain suspended, turning the waters of mountain lakes, such as McArthur Lake in Yoho National Park, an aquamarine blue.

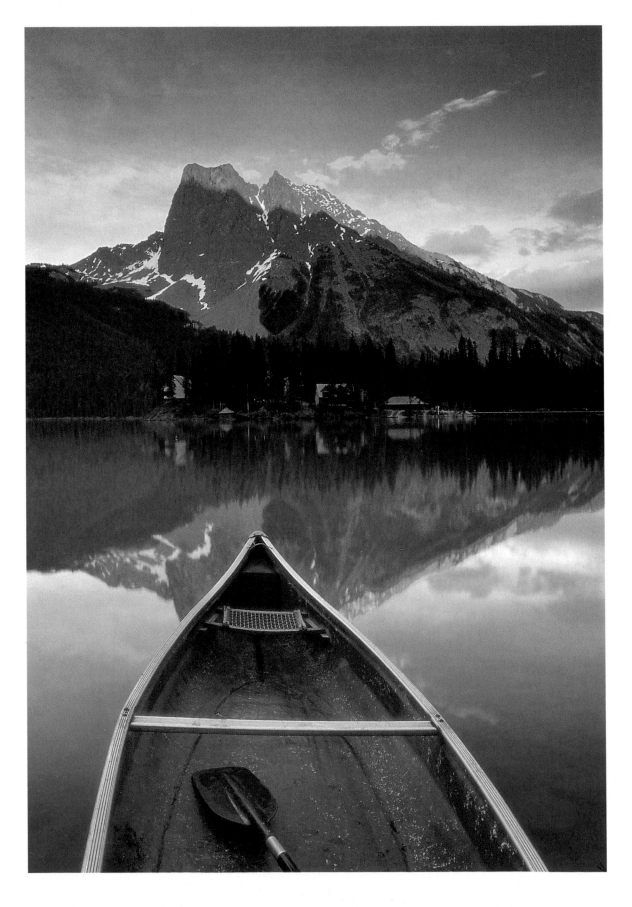

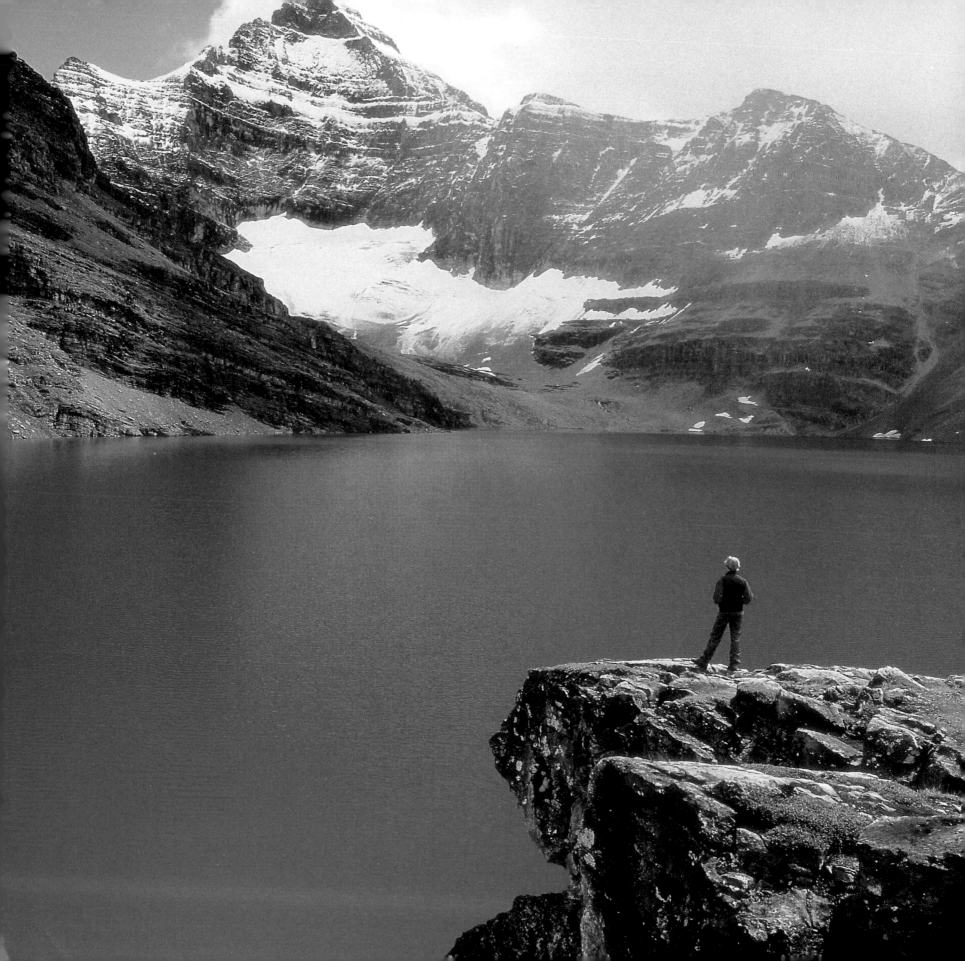

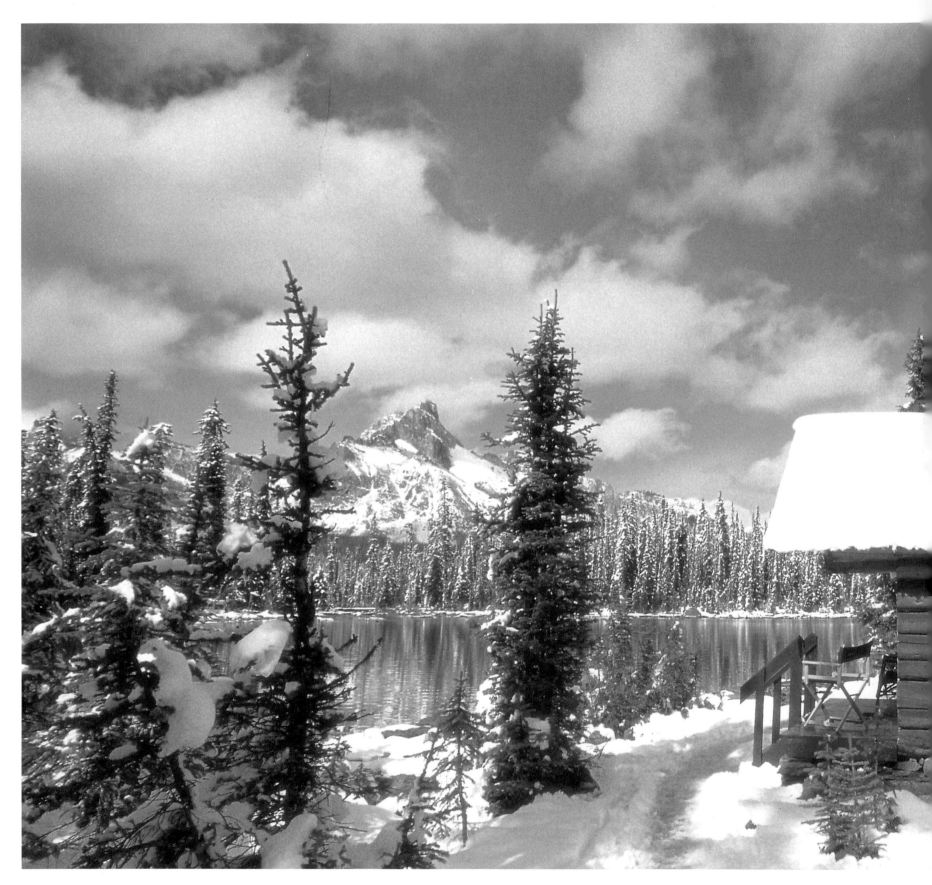

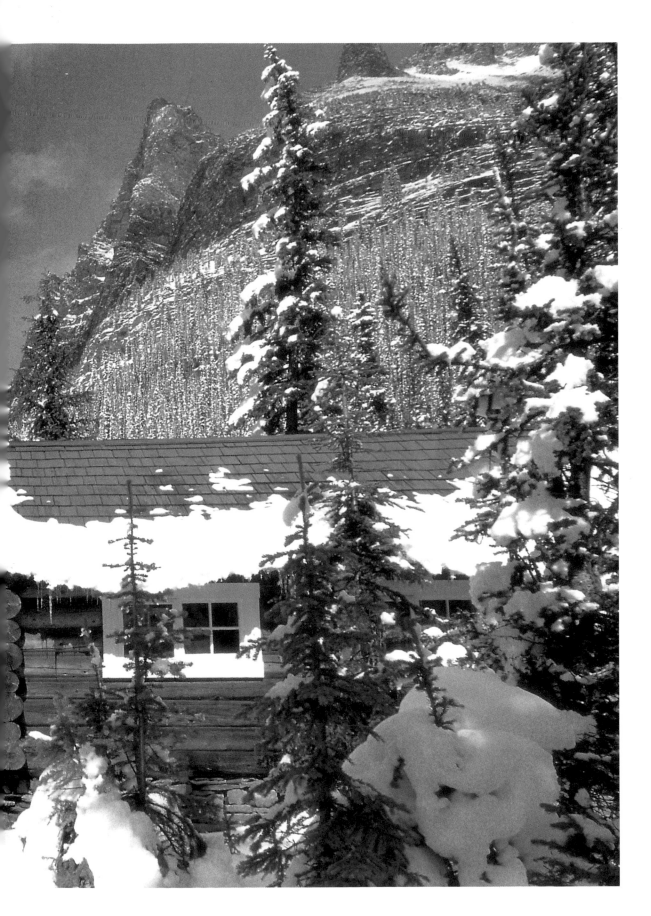

Snow surrounds Lake O'Hara in Yoho National Park. Though the log cabin at the shore is definitely more popular in summer, a few cross-country skiers appreciate the winter shelter.